JANE L. DOOLITTLE
14 YARROW PLACE
MT. LAUREL, NJ 08054-6916
856-273-0598

LIGHTHOUSES

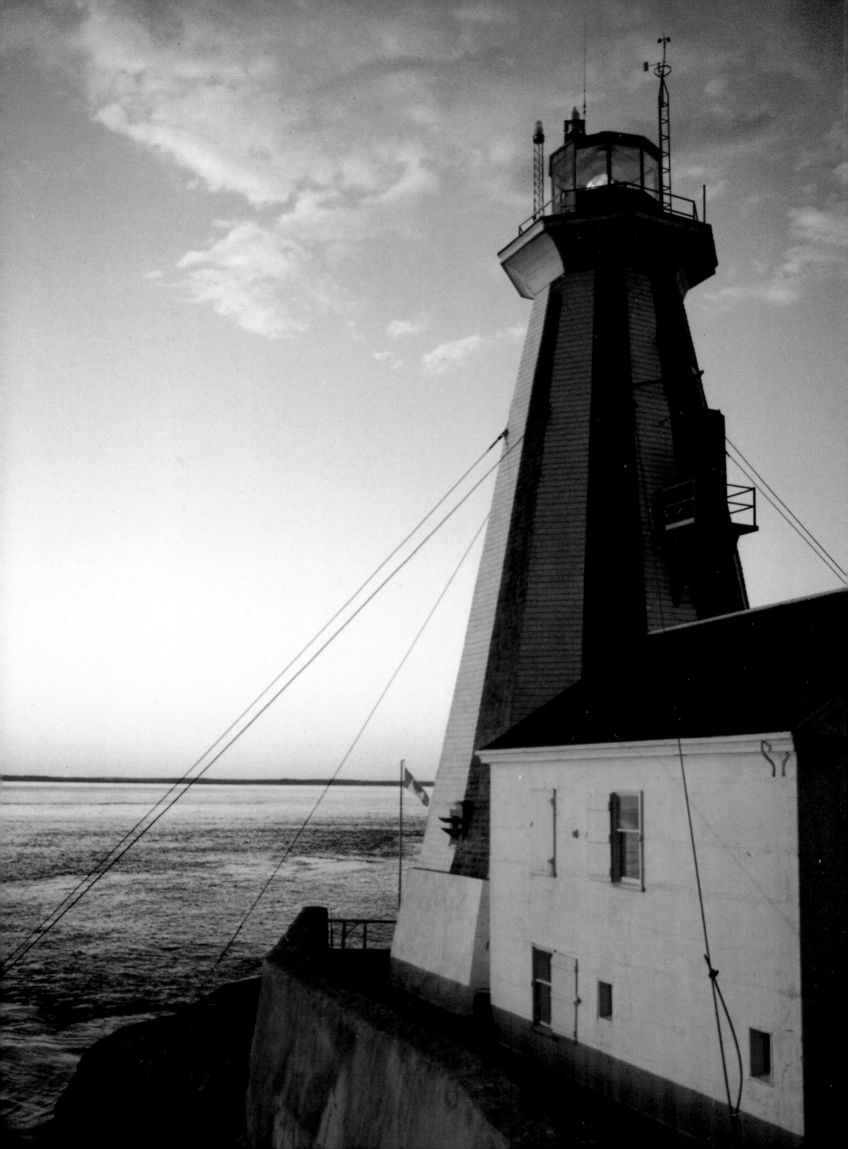

LIGHTHOUSES

Leo Marriott

SMITHMARK

Page 2: Gannet Rock, New Brunswick, Canada

© 1999 PRC Publishing Ltd

This edition published in 1999 by
SMITHMARK Publishers,
a division of U.S. Media Holdings, Inc.,
115 West 18th Street, New York, NY 10011

SMITHMARK books are available for bulk purchase for sales promotion
and premium use. For details write or call
the manager of special sales,
SMITHMARK Publishers,
115 West 18th Street, New York, NY 10011

Produced by PRC Publishing Ltd
Kiln House, 210 New Kings Road, London SW6 4NZ

ISBN 0 7651 1686 3

Printed in China

10 9 8 7 6 5 4 3 2 1

Library of Congress CIP (when available)

Printed and bound in China

CONTENTS

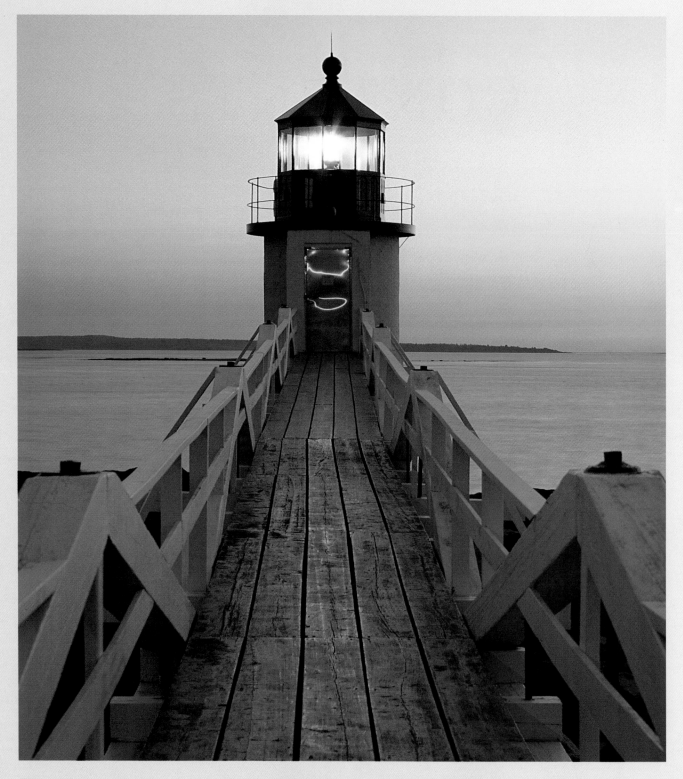

NTRODUCTION

The modern mariner has little difficulty in finding his way around the sea routes of the world and along coastlines which, in the past, would have presented constant dangers to a ship and all aboard her. Not that the dangers have been removed, but rather they have been tamed and confined by technology. The art of navigation has been revolutionized, particularly since World War II, by various electronic aids such as Loran

Above: Marshall Point, Port Clyde, Maine, US.

and Decca. Even quite small yachts and fishing boats carry a full outfit of radios for communication, as well as radar to see and identify coastlines and other vessels and sophisticated echo sounders that produce 3-D digital maps of the seabed below the keel. Perhaps the greatest revolution is the satellite-based Global Positioning System (GPS) through which a sailor can have an instant and continuous readout of his position on the surface of the earth to an accuracy of ten yards or less. With access to all this technology, a vessel can make its way across hundreds or even thousands of miles of sea and ocean and make a safe and precise

Above: St Simon's, Georgia, US.

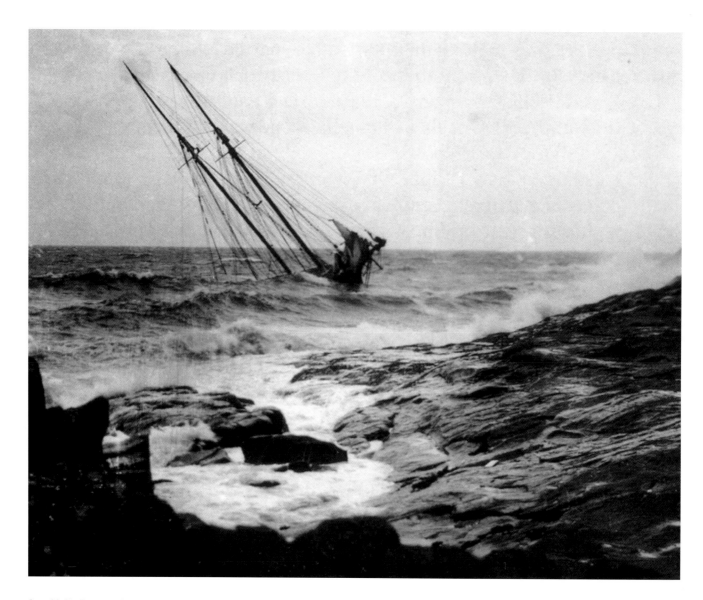

landfall. It can then navigate close inshore and enter a port or harbor—and all this can routinely be accomplished without any visual reference to the shore.

Of course it was not always so. The early mariners were intrepid and brave, perhaps even foolhardy, to an extent that cannot be fully appreciated today. Their ships were small and primitive, unable to sail close to the wind, and often dependent on oars or sweeps for progress when the wind died or was unfavorable. When a storm or gale blew up, they had little choice but to run before it and hope that their fragile craft would not be smashed by the power of the waves. If the storm lasted more than a few hours, they could be blown far away from their intended course with no method of establishing their position. Navigation was by simple dead reckoning, based on a crude measurement of speed, and a course set by following the sun or the stars,

although the curious properties of the lodestone (a crude compass made from naturally magnetized iron-bearing rock) were quickly adopted by seafarers.

As the ancient sailor approached his destination, his problems grew. While sailing in open waters, the hazards were confined to the weather and the sea, but as he approached the shore, uncertain of his position, a series of hazards lay in wait. Dangerous rocks and reefs gave no warning of their presence and, even if they did appear on early charts, there was no way that a ship's position could be established with certainty. At night, things were even worse. The unsuspecting sailor might run into rocks and cliffs, not seeing them until it was too late to alter course or stand off. Even if it was daylight and the shore became visible, it was often difficult to establish the identify of features in view, especially if the sailor was unfamiliar with that part of the coast.

Above: The wreck of the *Agnes C. Donahoe*, lost off the coast of Nova Scotia, Canada. Close to the shore, razor sharp rocks can bring catastrophe upon the unwary sailor.

Despite all these dangers and difficulties, the sea was still a highway for goods and people, and in many ways it was an easier form of travel than overland, which could be just as hazardous in different ways. In addition, even a very small ship could carry a significant weight and volume of cargo that would have been difficult, or even impossible, to carry on land by means of wagons and horses in ancient times.

Consequently, maritime trade flourished, and many cities and small nations grew rich on the skill and

Above: Green Island, British Columbia, Canada

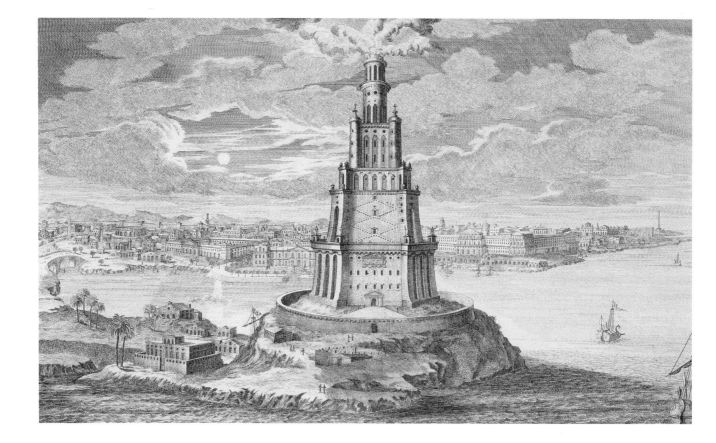

daring of their sailors. The Mediterranean Sea provided passage for the ships of the earliest civilizations, and quite significant voyages could be made without being too far from land. Nevertheless, ships all too often sank in storms and others became lost and hit rocks, reefs, shoals and cliffs, usually with a heavy loss of life and almost invariably causing valuable cargo to go to the bottom.

As always, necessity became the mother of invention, and the development of ships was accompanied by establishment of aids and devices to assist in their safe navigation. One of the most obvious needs was a physical marker on the shore to pinpoint the entrance to harbors and to mark the position of rocks and hazards. Such markers might vary from simple piles of stones to gigantic and ornate structures that were, quite literally, some of the wonders of their time. Perhaps one of the best known of these was the Colossus of Rhodes, completed in 282BC, a statue over 110 ft (33 m) high in the form of the sun god Helios.

The island of Rhodes enjoys an excellent strategic position in the Mediterranean and its people have made a living from the sea since the earliest times. Over the

centuries it flourished as an important trade center and in 408BC Ialysos, Lindos and Kamiros, the island's three Doric cities, agreed to form the city of Rhodes. The newly founded city then forged an alliance with Ptolemy I Soter of Egypt, and in 305BC successfully withstood a siege by the Antigonids of Macedonia. In the following year, the Macedonians were defeated and much captured booty was sold, the funds raised being directed to the building of the statue of Helios. Work did not commence until 294BC and took twelve years to complete.

It is commonly believed that the resulting Colossus of Rhodes, one of the Seven Wonders of the Ancient World, straddled the harbor entrance, but modern investigations have destroyed this romantic myth. In fact it probably stood on a promontory to the east of Rhode's Mandraki harbor. The base was of marble, but the statue itself was of bronze and encased an iron and stone framework. The exact form of the statue is unknown, as no contemporary drawings survive, but modern historians have conjectured that it was in the shape of an upright man holding a torch aloft. It is claimed that this was the inspiration for the French

Above: The Pharos lighthouse of Alexandria, one of the Seven Wonders of the World. This monumental prototype lighthouse was completed in about 280BC, and was roughly 384 ft (117 m) high. The light arrangement of a fire reflected by mirrors was supposedly designed by Archemedes and could be seen for about 20 miles (32 km).

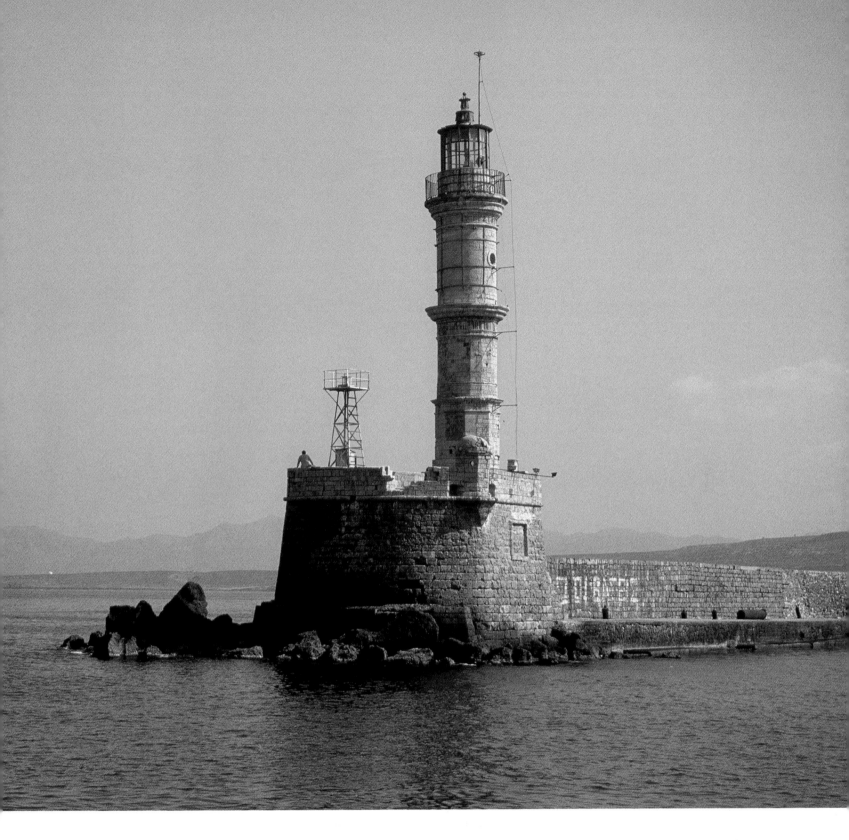

sculptor Auguste Bartholdi, who was the designer of the Statue of Liberty.

In any event, the statue would have provided an unmistakable feature for Mediterranean sailors, long before the harbor itself came into view. By day, the sun shining on the burnished bronze would have made a sight to awe even modern eyes, and at night fires lit in the torch reputedly held aloft by the figure would literally have provided a guiding light. Unfortunately, however useful the Colossus may have been to sailors, it was to be short-lived. It was toppled by an earthquake that badly damaged the city in around 226BC. The statue itself broke at the knee and lay in ruins on the ground. The Egyptian ruler of the time, Ptolemy III Eurgetes, immediately offered financial and material help to re-erect the Colossus (which was no doubt just as useful to his own sailors), but his offer was declined after the islanders consulted an oracle who delivered a discouraging prediction. The fallen Colossus lay in ruins for almost a thousand years before it was broken up

Above: Lighthouse in the harbor of Khania, Crete, Greece.

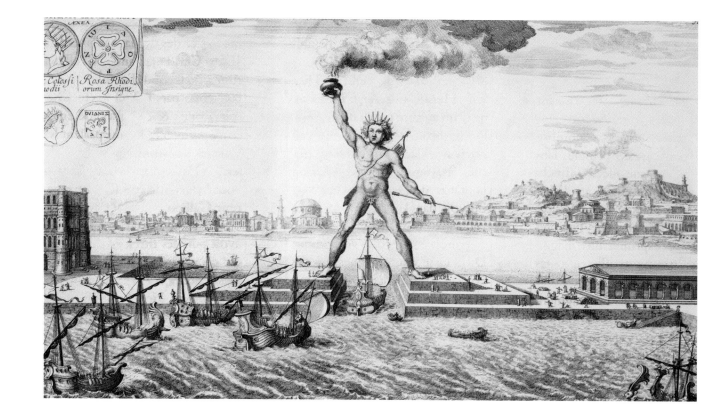

following an Arabian invasion of Rhodes in AD654. According to some reports, the fragments of stone and metal were transported overland to Syria by over nine hundred camels.

If the Colossus was short-lived, another marvel of the ancient world had a much longer and useful career. This was the Lighthouse of Alexandria, built around 285BC at the instigation of the Egyptian king Ptolemy Soter, and completed a few years after the Colossus of Rhodes. It was much larger than the Colossus, however, consisting of three stages with a combined height estimated to have been around 384 feet (117 m). It was the tallest building on earth at the time, and it was almost certainly the first major structure solely and specifically designed as a lighthouse. The port of Alexandria was important to Egyptian trade and commerce but difficult to locate from the sea against a uniform and featureless hinterland. The massive lighthouse provided a day marker that would have been visible from over 20 miles (32 km) away, especially because a massive mirror was fitted at the top of the structure to reflect the sun's rays out to sea. At night a fire was lit to provide additional guidance and the central core of the building incorporated a hoist to lift fuel to the upper platform. A statue of the sea god Poseidon

surmounted the whole structure. The lighthouse was built on a small island known as Pharos and this name became synonymous with the original lighthouse and, indeed, passed into many Mediterranean languages with that meaning.

The Pharos at Alexandria remained in service for centuries until the Arabian invasion in the seventh century, when its usefulness declined. The mirror was removed and not replaced although the tower withstood an earthquake in AD956. In the early fourteenth century, two major earthquakes caused serious damage, and the lighthouse partially collapsed. Finally, in 1480, work began on demolishing the ruin, and the stones were used in the construction of a substantial fort under the direction of the Egyptian Mamelouk Sultan, Qaitbay.

The demise of the Egyptian and Greek civilizations was followed by the rise of the great Roman Empire, which spread across almost the whole of Europe, as well as parts of North Africa and the Middle East. The Mediterranean was at the heart of the empire and the Romans relied heavily on seaborne trade. Given the Roman expertise in many fields of civic architecture and engineering, it is not surprising to find that the Romans also built several lighthouses, though none of

Above: The Colossus of Rhodes, another of the Seven Wonders of the World, was believed to have carried a light to guide mariners.
Right: The Cabo Sao Vincente, Portugal.

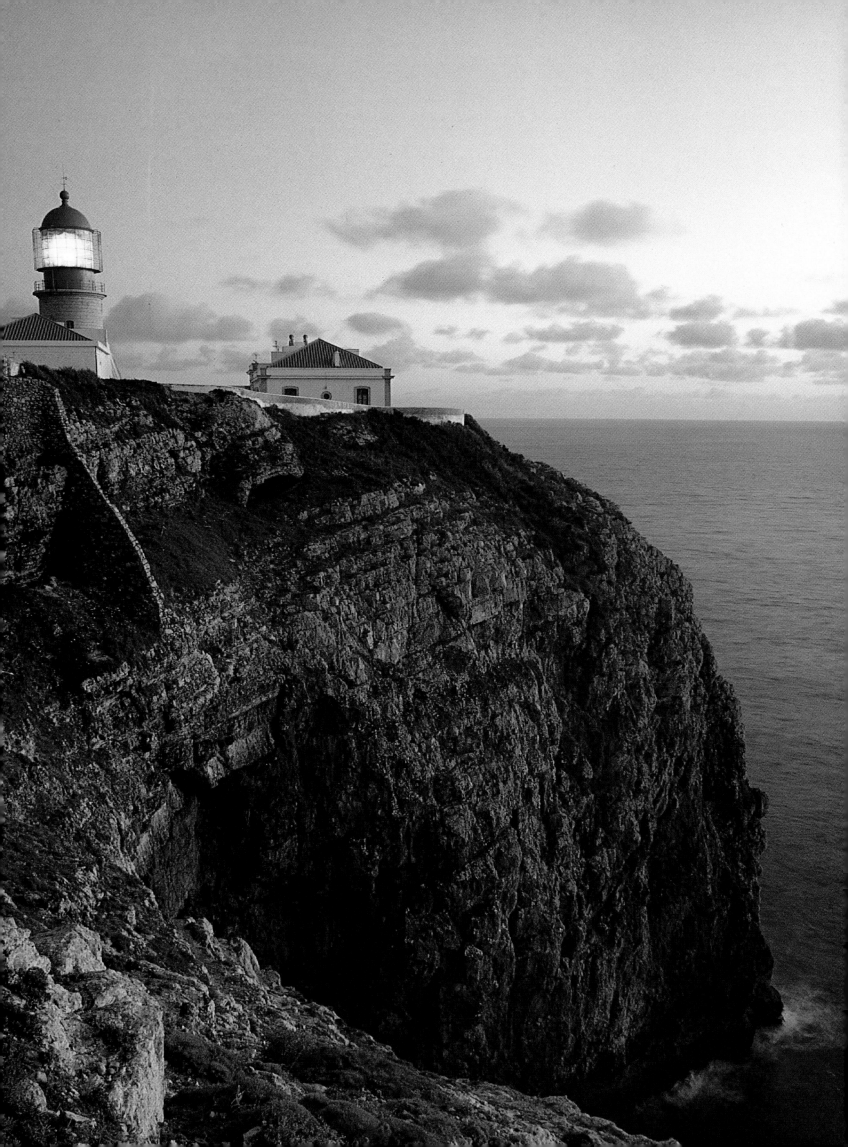

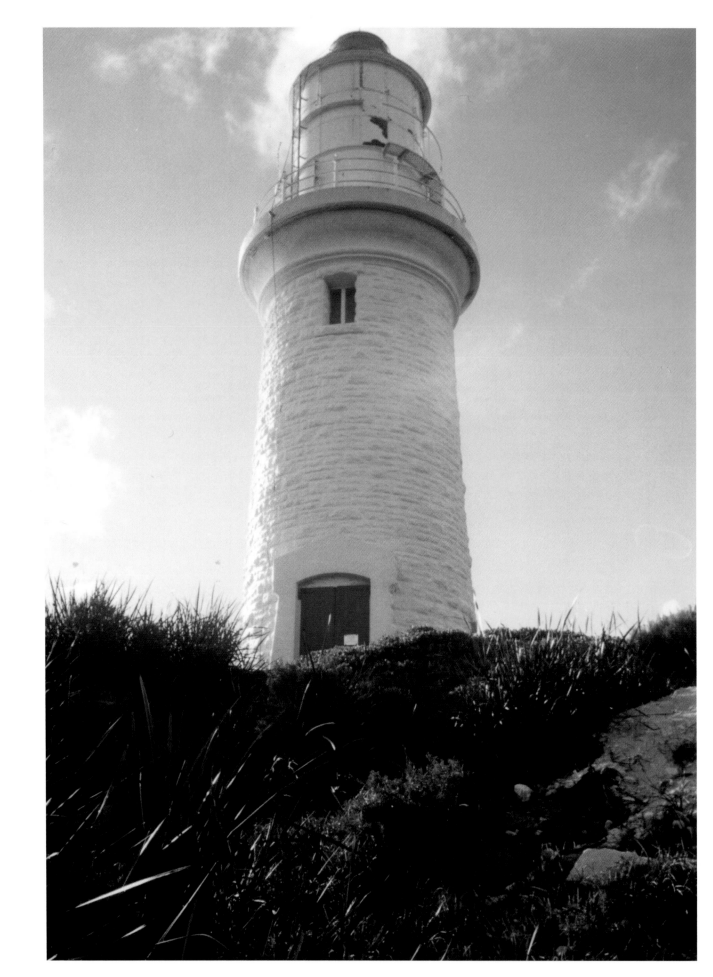

Above: Bathurst Point on Rottnest Island, Western Australia.

these were on the scale of the Pharos at Alexandria. They were simple "fire" towers. Several were erected on the North African Coast and, as the empire spread into Iberia and Gaul (Spain and France), others were erected on the Atlantic Coast. One of these was at La Coruña on the Northwest tip of Spain, and the existing lighthouse in that location incorporates some of the original Roman construction, making it the oldest working lighthouse in the world.

Further north, a light tower or pharos was erected at Bolougne in AD44, while a similar one was built at Dover in England in AD53 during the reign of the Emperor Claudius—and this one still stands today. It is thought that the prime function of these towers was for signaling purposes, but there are also firm records of their being used as lighthouses.

Thus for many centuries the Romans regulated most of the European maritime trade and provided for its safety with many fine harbors and numerous lighthouses. As with all empires, however, its power eventually waned and by the end of the fifth century, the Roman Empire had all but disappeared while Europe was plunged into the anarchy of the Dark Ages. In terms of maritime lights, the term "Dark Ages" was all too accurate, as there is little evidence of any lighthouse being built, or indeed of existing ones being regularly attended. In much of Europe it was only at locations inhabited by religious orders that a light for the benefit of mariners was maintained, although these were often simple beacons rather that any form of permanent building. In any case, it was extremely common for unscrupulous people to burn false lights in order to lure ships onto rocks, whereupon the wreck could be looted and, if necessary, the survivors murdered. Such activities were extremely common and, despite the passing of laws threatening dire punishment for such perpetrators, they continued even in countries such as England and France well into the eighteenth century.

It was not until the tenth or eleventh century that civilization began to re-establish itself, and Europe slowly dragged itself out of the nightmare of the Dark Ages. As it did so, maritime trade began to revive, and in the forefront were the city republics of Italy,

ideally placed to monopolize the carriage of cargoes throughout the Mediterranean. It was here that major new lighthouses were erected at the start of the twelfth century, including a particularly fine example at the port of Genoa completed around 1130. This was replaced by a new structure in 1544 that still stands today. Apart from its age, this lighthouse is also unique in being the tallest masonry (brick) lighthouse in the world, measuring some 245 feet (74.7 m) to the top of the tower. Its overall height is increased by a statue of St. Christopher and a lightning conductor. The only lighthouse in the world that is taller is one at Yokohama, Japan, which reaches up to a height of 348 feet (106 m) but this is a steel lattice structure. The Italians can also claim to have built the first wave-washed rock lighthouse, on a dangerous shoal at Meloria near Porto Pisano (Pisa). Just north of Leghorn, Porto Pisano was an important outlet for the towns of Tuscany. The lighthouse was erected in 1157, but it was destroyed a little over a century later, in a war between the Pisans and Sicilians led by Charles of Anjou. When more peaceful times returned, it was replaced by a new lighthouse built on a rock in the port of Livorno. Other important lighthouses were erected during this time at Messina (Cape Pelorus), where ships of the Crusaders were guided through the straits between Sicily and the Italian mainland; Venice, which was becoming an important city-state and center of trade; and the Bosphorous, where several pre-existing Roman lighthouses were replaced with newer structures to assist ships passing through the Dardenelles to the Black Sea.

In medieval times Britain was not the great maritime power it was later to become, but nevertheless there was a substantial amount of commercial trade as well as numerous fishing boats. In 1314, a ship carrying a cargo of wine from a monastery in Picardy, was wrecked on the cliffs at the foot of St. Catherine's Point, the southernmost tip of the Isle of Wight. The crew managed to struggle ashore, and when the weather abated, they salvaged much of the cargo and then sold it to the islanders, subsequently telling their masters that all had been lost when the ship was wrecked. Unfortunately for them and the islanders, this early maritime fraud and

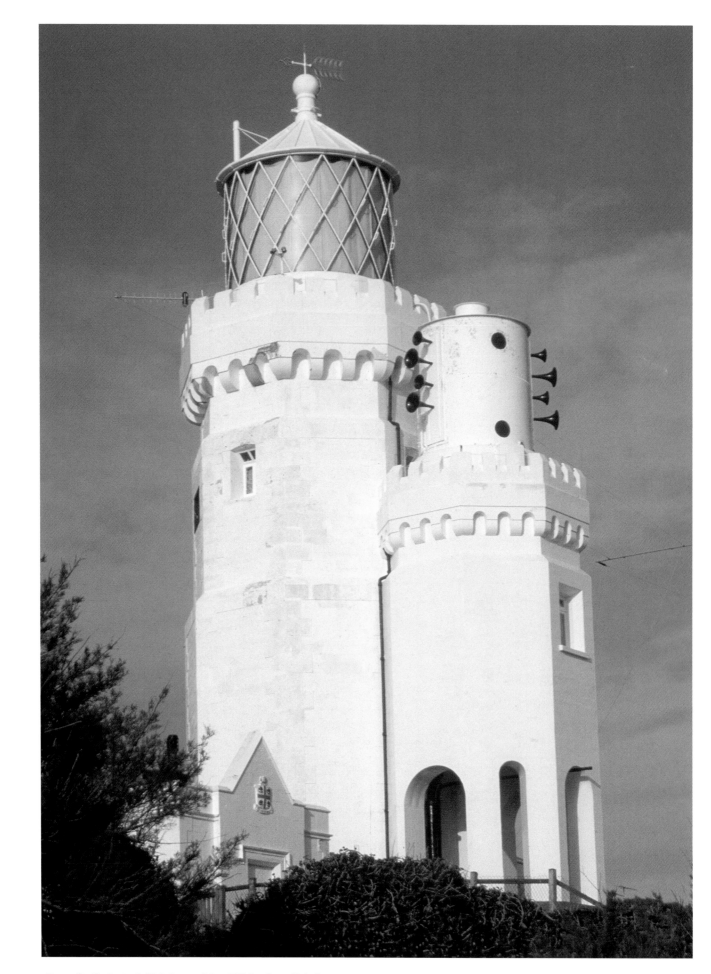

Above: St. Catherine's Lighthouse, Isle of Wight, Great Britain.

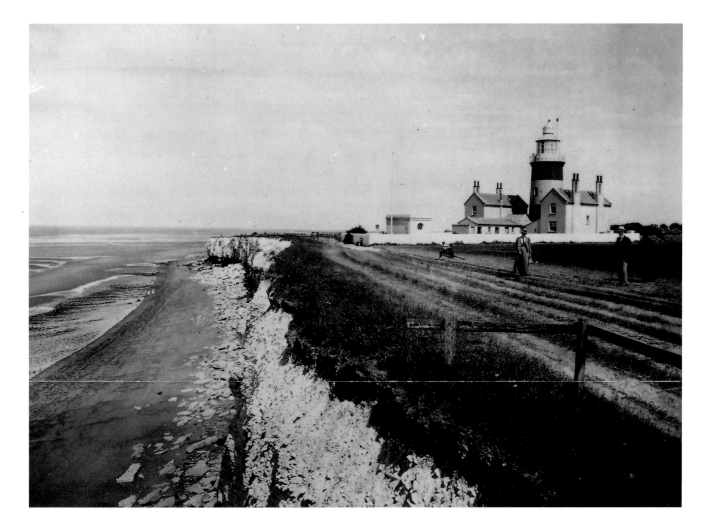

insurance scam was discovered, and an ecclesiastical court, claiming jurisdiction as the cargo belonged to the church, fined a local squire named Walter de Godeton and two accomplices the sum of 227 marks. In addition, de Godeton was ordered to build a lighthouse at the top of the cliffs and provide for a priest to live there and tend the light. By 1328, this lighthouse was built and the structure still stands today, although it is not known how it was actually used for it intended purpose.

It was not until the sixteenth century that any official lighthouse was built in England. In 1536, King Henry VIII granted a charter to a Guild of the Blessed Trinity at Newcastle to erect and maintain two towers, one on either side of the entrance to the River Tyne, which would burn coal or wood at night for the benefit of local mariners. In 1594, these were supplemented by a larger light tower within the grounds of Tynemouth Castle. Other maritime guilds were also in existence at this time, notably the Brotherhood of Trinity House at Deptford, which was concerned with traffic on the

River Thames. Out of these separate organizations grew the present day Trinity House, which is now responsible for the building and running of all British lighthouses.

The first lighthouse to be built under the auspices of Trinity House was at Lowestoft in 1609. The medieval tower at Tynemouth fell into disrepair and was replaced in 1664 by a much more imposing square structure some 78 feet (23.8 m) high, which survived until 1894, when it was demolished following the commissioning of a new lighthouse at St. Mary's Island a few miles to the north. Other significant lighthouses of the period were built at North and South Forelands in 1636 and at Flamborough Head in 1674. In Scotland, a square tower carrying an open brazier light was built on the Isle of May in the Firth of Forth in 1636, and a significant portion of it still stands today. In the Firth of Clyde, a circular light tower was erected in 1757, and this remains carefully preserved today although the keeper's cottage alongside is a ruin. In the eighteenth cen-

Above: The lighthouse at Hunstanton, Great Britain, 1899.

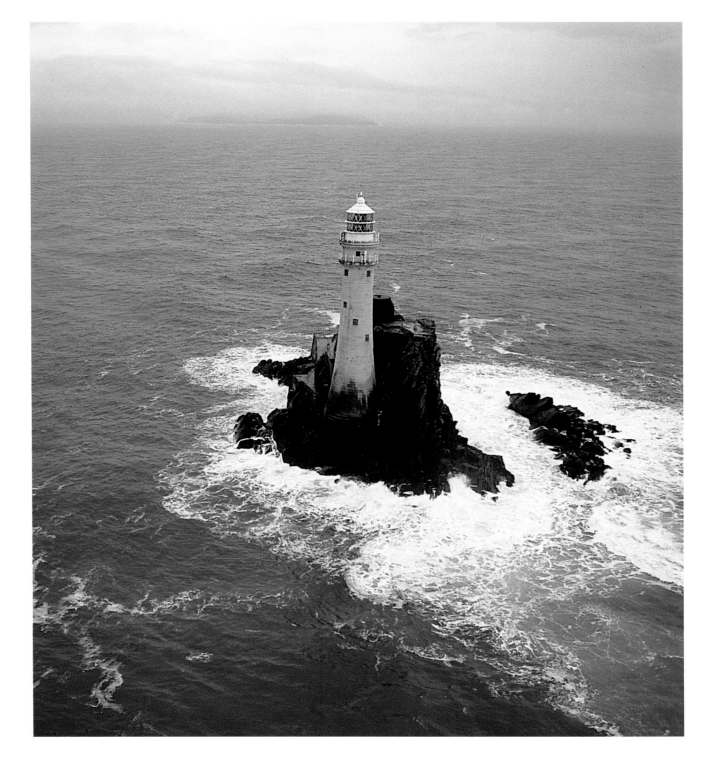

tury, many more lights were erected including the first of many on the famous Farne Islands in 1776, St. Ann's Head at the entrance to Milford Haven in 1713, and Flatholm in the Bristol Channel in 1739.

Of course all of these structures were built on land, or at least on substantial islands. However, the ultimate success of the Eddystone lighthouses in the seventeenth and eighteenth centuries paved the way for others to be built in various difficult offshore locations,

such as Bell Rock in the Firth of Forth, Skerryvore of the Isle of Tiree, Bishop Rock near the Isles of Scilly, and the Fastnet Rock off the south coast of Ireland. Most of these were built in nineteenth century and were of masonry construction, granite being the best material. However, in other parts of the world, notably Southern France and the Mediterranean countries, brick was a popular material. Many medieval structures were built of wood and consequently few, if any, sur-

Above: Fastnet, County Cork, Ireland.

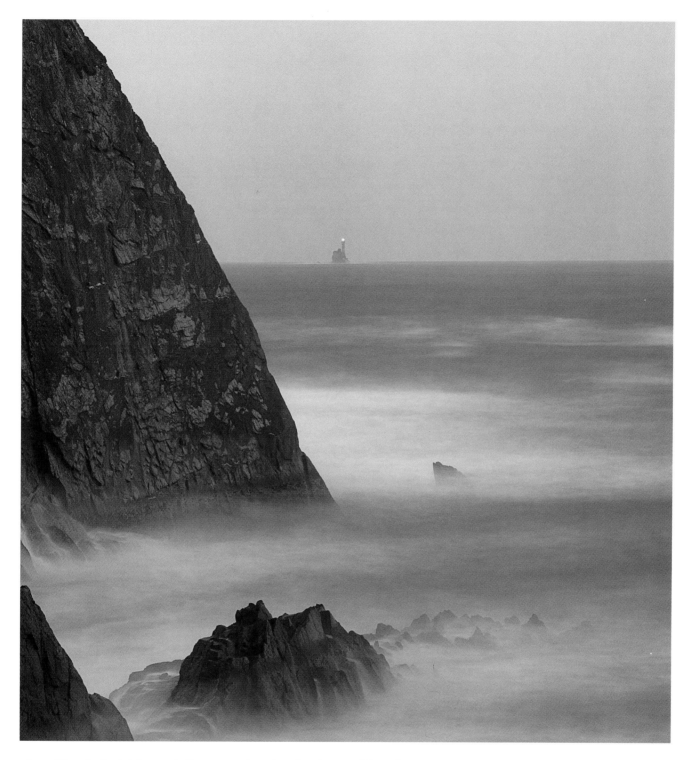

vive. The industrial revolution, starting in the late eighteenth century, introduced the use of iron as a building material and this was often used to form piles or supports for lights and beacons. A complete octagonal ironclad tower was erected at Swansea in 1803, but it was demolished many years later. On the Cumbrian coast an iron lighthouse dating from 1834 remains at Maryport. By the mid-nineteenth century, prefabricated iron towers could be manufactured and

shipped to various parts of the world for erection. One was installed at Morant Point in Jamaica in 1842, another at Gibbs Hill, Bermuda in 1846, and another on South Point, Barbados in 1852. Others were exported to places as far apart as South Africa, New Zealand, and China.

The great building material of the twentieth century is concrete and most modern towers are built of reinforced concrete sections, a typical example being the

Above: Fastnet, County Cork, Ireland.

Dungeness lighthouse built in 1965. In open waters, concrete-filled caissons are sunk to the seabed to form the foundations for further concrete sections above. Often these are assembled in the form of a foreshortened telescope with concentric circular sections. Once sunk on the seabed, the center sections are floated up, the space below being filled with more concrete and ballast. Scandinavian engineers pioneered this method, and a typical example can be seen at Grundkallen in Sweden. An advantage of this method is that the lighthouse can be built and almost completely fitted out ashore and then floated to its required location. One of the best examples in British waters is the new Royal Sovereign lighthouse, which was commissioned in 1971. In this a telescopic caisson was towed out and sunk and the center portion slightly raised. A completely prefabricated lighthouse incorporating light, living quarters, stores, and a helicopter landing deck was then towed out and attached to the top of the caisson center section, which was then jacked up and secured while the base was ballasted and sealed.

While the construction of and design of lighthouses has a fascinating history, it must be realized that they were only a means to an end and the all-important factor was the light itself. In this day and age of almost unlimited sources of energy, the provision of a bright light such as that required by a lighthouse seems a simple matter, but it was not always so. The earliest lights utilized simple fires usually fueled by timber but also coal if it was available. However, anyone who has ever lit a bonfire will realize the problems involved. First of all, if the fire is to be kept burning continuously over a long period, it will require considerable amounts of fuel, especially for a bright flame to be produced. Fires can be kept smoldering but show little or no light. To be of any use as a light source, the fire must be continually stoked and replenished. If the fire is lit at the top of a tower, then every scrap of timber or coal must be laboriously carried up while the lighthouse structure would need to provide dry storage for the bulky fuel. Even if the fire could be sustained, it would not necessarily be visible at a great distance, especially if it was obscured by smoke due to the strength and direction of the wind. Despite these drawbacks, virtually all the lighthouses of the ancient world were basically fire towers and, surprisingly such lighthouses were still quite common well into the eighteenth century. The last open fire light in Britain was at St. Bees in Cumbria, which only fell into disuse in 1823. In Ireland, peat-fueled lights were common, and in Scandinavia fire lights survived until 1858, the last being at Rundsy in Norway. Some of the fire lights were quite sophisticated, with attempts made to enclose the fire behind a glass lantern and to control it by means of flues and ducts, which could be opened or closed according to the direction of the wind, while bellows were supplied for those occasions when the wind was calm.

A more convenient source of light in early times was the tallow candle, which could be enclosed in a small lantern. These sometimes lit up the windows of coastal churches or were used by the families of fishermen or other seafarers to help guide them back to port. A reflector made of copper or other bright, polished, metal could focus the relatively dim light of a candle. One or two such candles would provide a dim but visible light over short distances. When Henry Winstanley built the first Eddystone lighthouse in 1698, he designed the light source as a massive chandelier carrying no less than sixty large tallow candles. These required a considerable amount of attention when burning—the wicks needed trimming every hour and this was unpleasant and dangerous work in the hot and fume-laden confined space of the lantern. In fact it was the spontaneous ignition of such fumes that led to the destruction of Rudyerd's third Eddystone light in 1755.

Another light source known to the ancient world was the oil lamp. In its simplest form, it consists of a wick floating in a pool of oil, and variations on this were used, mainly for harbor lights, for many centuries. As time went by, various refinements were made; for example, a substantial oil-burning lamp existed on St. Michael's Mount in Cornwall during the fifteenth century. This substantial stone structure had mullioned windows that allowed the light to shine over an arc of 200°, its brilliance being increased by means of a stone-faced reflector. A significant improvement of the simple oil

Opposite top: A ship in a bottle made by Thomas King, the Skellig lighthouse keeper from 1896–99.

Opposite bottom: Skellig Michael showing the old lighthouse on the left and the new one in the center.

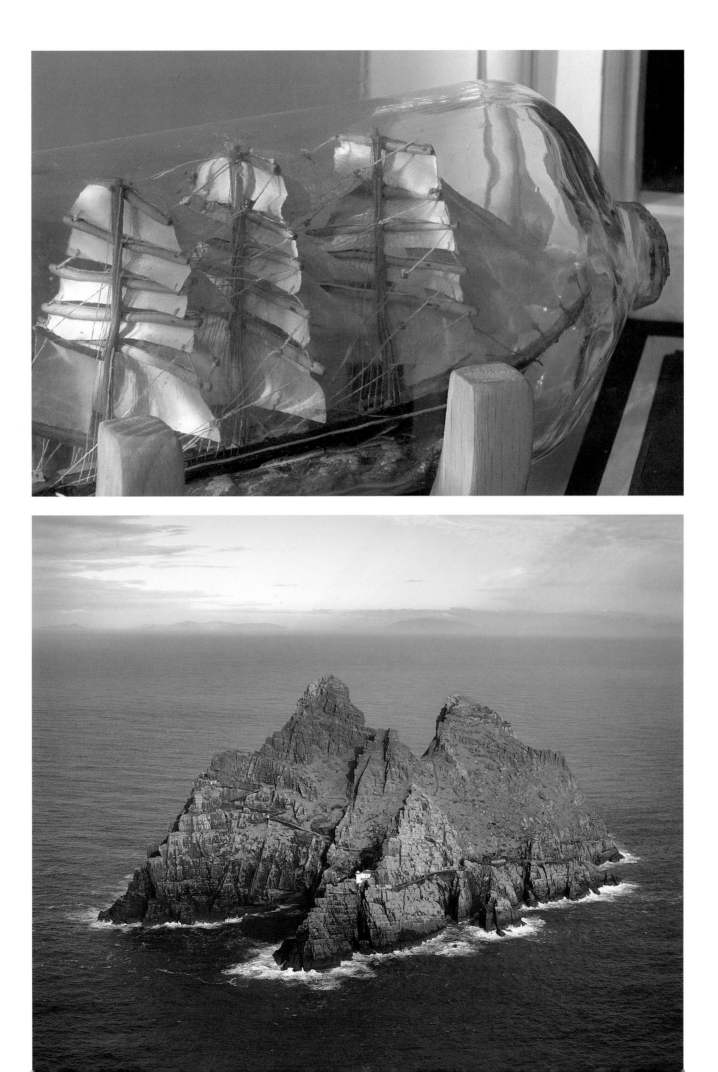

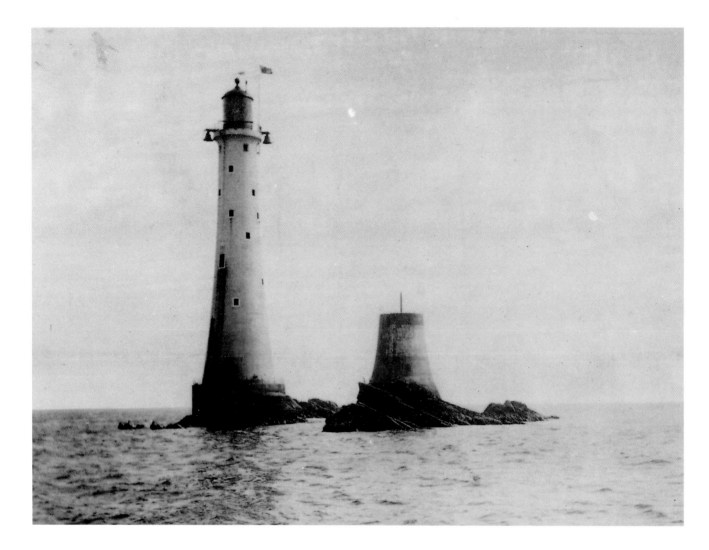

Eddystone, Great Britain, 1887.

lamp came about in the early eighteenth century, when it was realized that a vertical glass tube over the wick substantially increased the brilliance of the flame because of the forced draft which occurred. The transparency of the glass allowed the light to be seen. In 1784 a Swiss inventor, Ami Argand, produced a hollow circular wick that improved the airflow and produced a more even light. Subsequently oil lamps became quite sophisticated with several concentric wicks that could be raised and trimmed mechanically as they burned down.

The type of oil used varied tremendously. In the Mediterranean olive oil, or even fish oil, was quite readily available. In Northern Europe in the mid-eighteenth century, sperm oil from whales, supplied by the North American whaling fleets, was generally considered the best. Olive oil was tried experimentally at Liverpool in 1847 following reports of its successful use in Spanish and Austrian lighthouses. More widely

adopted in the nineteenth century was colza, an oil produced from rape seed, which could be easily grown in the required quantities, particularly in France where it was first used. The oil used in the Cape of Good Hope lighthouse was perhaps the most unusual of all—it was produced from the tails of sheep! Apparently it burned very brightly but was expensive to produce. The ultimate oil lamp fuel was paraffin, which was introduced in 1860 and rapidly became the standard fuel for most lighthouse lamps until well after World War II. Paraffin, or kerosene, was a by-product of petroleum, and it produced a flame up to ten times brighter than the equivalent colza lamp.

As an alternative to oil lamps, gas lighting was tried by various authorities. Italy was one of the first countries to use coal gas-fueled lights, mainly for harbor installations, one example being the Salvatore lighthouse at Trieste on the Adriatic coast. Subsequently it was tried in Britain, but was not widely adopted,

although in Ireland, where it was first installed in the Howth Bailey lighthouse in Dublin Bay in 1865, it was later used in six other lighthouses. Acetylene provided a much brighter light, but there were a number of problems to be overcome before it could be used safely. It was also expensive to produce, and therefore it was desirable that it should be used sparingly. This became possible when Gustav Dalén invented a regulator valve that only opened when daylight faded. His company, which produced this device, was AGA, better known today for its sought-after cooking ranges! The final link in the development of oil or gas fuel lights was the invention of the incandescent mantle in which pressurized paraffin or gas produced a very intense flame that heated an impregnated fabric material surrounding the flame. This glowed incandescently and produced a light at least three times the intensity of previous lamps—and used half the amount of oil or gas.

Thus refined, the oil lamp was the main source of light, certainly in British lighthouses, until well into the twentieth century, despite the discovery of electricity by Faraday in 1831 and the installation of the first electric powered light, at South Foreland, in 1858. While superficially electricity might seem to have been the ideal solution to providing power for lighting, the practicalities were more complicated. Lighthouses were often in remote locations and needed to be reliable and self-contained. This meant that they would need their own generators and early examples were not particularly reliable. In addition a method of powering the generator was required—normally a steam engine and this in turn was prone to breaking down and needed its own supply of fuel which had to be constantly replenished. By comparison the oil-burning lamp relied only on a suitably sized tank and a means of pumping the oil to reservoirs on the lights. Although a further lighthouse, Dungeness, was modified in 1862 to use electricity,

Above: This diagram from April 8, 1887, shows the Poolbeg Lighthouse, County Dublin, Ireland.

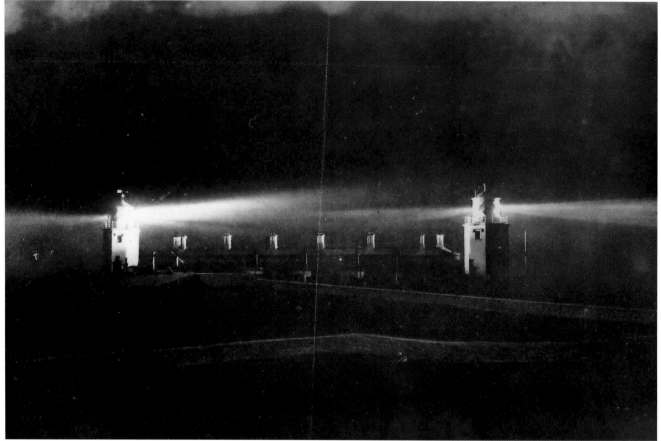

Trinity House stopped any further development for a while, and it was not until 1871 that the Souter light on the Lizard peninsula was refitted as an electrically-powered light. Although this installation was successful up to a point, it was not repeated as the carbon rod arc lamps were troublesome and did not give off as much light as the mantle-burning oil lamps.

Some of the problems surrounding the generating of electrical power were solved when transmission by power lines became more common. It then became relatively easy to supply electricity to shore-based light-houses and the development of high-powered filament lamps made the light source more constant and reliable. Nevertheless, provisions had to be made for unexpected power failures; for example, in Sweden, a lighthouse off Karlskrona was fitted with a standby acetylene gas system in 1933. This came into operation automatically in the event of an electrical power outage. Other devices were designed to cope with bulb failures by automatically revolving the unit so that a new light bulb was positioned. Despite such advances, the establishment of electricity as the main source of energy for the

light systems did not happen until the latter part of the twentieth century. In Britain, for example, electrical power did not become the norm until the 1970s.

Today, modern technological developments, such as the xenon discharge-lamp, can produce exceptionally bright light sources that can be seen at ranges in excess of twenty miles (32 km) in daylight and much further at night. These require less energy than conventional lamps and are also much smaller, requiring lighter and less complex optics.

The provision of a light source was not the only aspect of lighthouse development to receive detailed attention. Much of the light energy is wasted if it is allowed to radiate in all directions and only a small fraction would be visible when viewed from a particular direction. From the earliest days, therefore, efforts were made to concentrate the light so that it could be seen from greater distances or better penetrate conditions of rain, mist, and fog. The most simple method of doing this was to place a reflecting surface behind the light so that its brightness was increased. A mirror of polished copper was originally installed on the Pharos

Above: The lighthouses at Lizard, Cornwall, Great Britain, 1887.

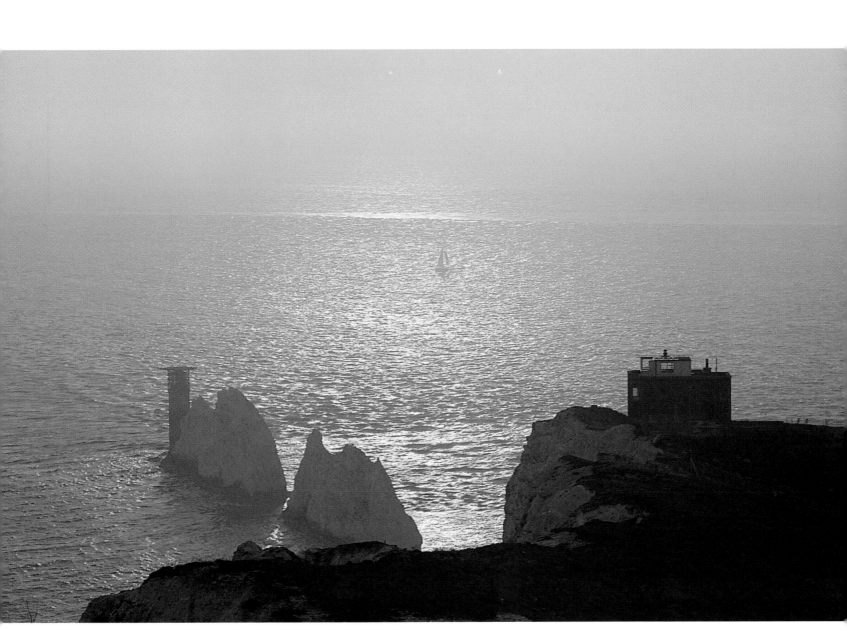

of Alexandria, and the idea was occasionally applied to other lights. In general, though, most lights were unassisted by any means of augmentation until the late seventeenth century when the idea of using spherical or parabolic reflectors was applied to marine lights in Sweden. In England, the first parabolic reflector, designed by William Hutchinson, was fitted in 1763 to four lights around the port of Liverpool, while in France the first silvered copper parabolic reflector of great efficiency was developed by M. Lenior and fitted to the La Héve lighthouse in 1781. The concept of concentrating the light by means of mirrors or reflectors is termed catoptric and such devices could be quite large. At the start of the nineteenth century the light at Bidston on the Mersey estuary had a reflector no less than thirteen feet (4.11 m) in diameter. If the light was to be omnidirectional, then a series of lights backed by parabolic reflectors would be arranged in a circle and this could be a complex and expensive arrangement. One way round this was the *fanal sideral*, which consisted of two cones whose sides were of parabolic section with one inverted over the other so that their points were close together. The light source was placed at this point and would be reflected throughout 360° in the horizontal plane with little vertical dispersion. This system was invented in France in 1819 and for a long while was used extensively for small harbor lights.

While reflectors certainly increased the efficiency of lights many times over, a further improvement was obtained by the introduction of the optical lens as is common today in devices such as torches and car head-

Above: The Needles at sunset, off the Scilly Isles, Great Britain.

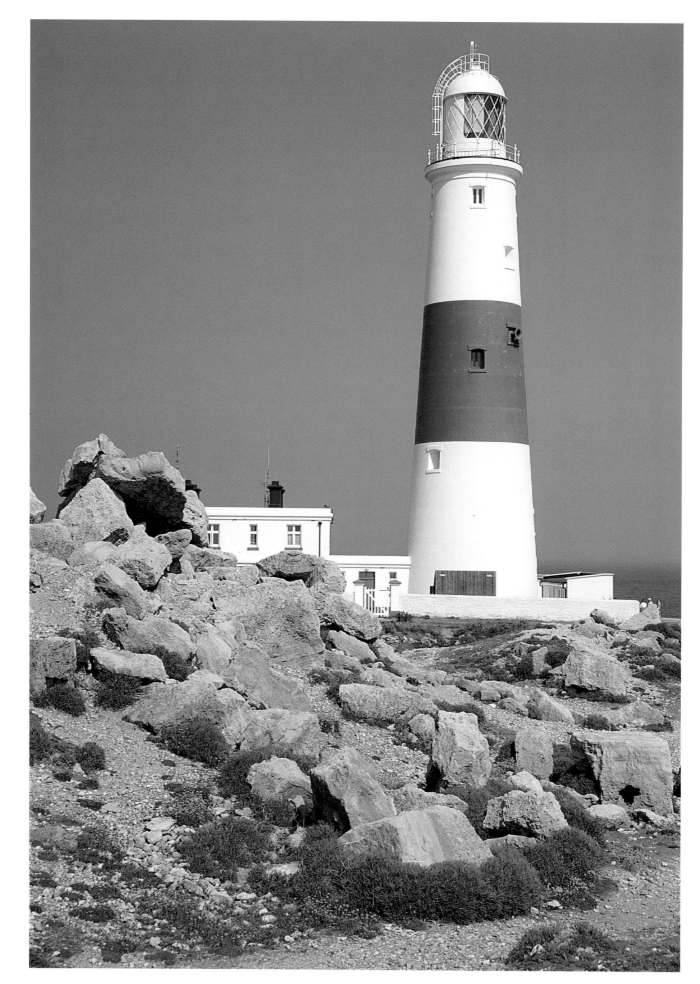

Above: Portland Lighthouse, Dorset, Great Britain.

lights. The lights at Portland and Dungeness in England were among the first to be so fitted, the latter being equipped with no less than eighteen reflectors, each carrying an Argand oil-burning lamp. Although such installations worked, they were expensive to clean and maintain and this was becoming an important consideration as sea trade began to expand rapidly in the early nineteenth century following the end of the Napoleonic wars.

It was Frenchman Augustin Fresnel who devised the modern Dioptric or refracting lens that bears his name. An ordinary solid circular lens became very large and heavy if produced in a suitable size for lighthouse purposes and, in any case, concentrated the light into a single unidirectional beam that was not necessarily best for maritime purposes. To compensate for these inadequacies, Fresnel's innovation split the circular lens into concentric rings of triangular cross section prisms which greatly improved the efficiency of the lens while reducing its weight and bulk. More significantly, he realized that the whole shape and form of a lens could be adapted to various purposes. For lighthouses, the prisms could be arranged in horizontal rings around the light source so that, with careful design, any light emitted would be refracted onto the horizontal plane. In an initial experiment, a Fresnel

dioptric system increased the intensity of a twenty-candle power light by an incredible factor of five hundred. This effectively meant that a bright omnidirectional light could be generated by a single source; consequently, such lights would be significantly cheaper to run and maintain. In July 1823, Fresnel installed his new system in the Cordouan lighthouse at Bordeaux, and the Isle of May light in Scotland's Firth of Forth was similarly equipped in 1825. English lighthouses administered by Trinity House were so fitted from 1836 onward.

Fresnel subsequently produced the improved catadioptric system in which the prism section refractors concentrated the light, which then passed through a central spherical lens section, while other developments included the use of reflectors within the Fresnel lens system. By the mid-nineteenth century, such lens systems became virtually standard and a considerable industry developed to manufacture them. In Britain, the Chance Brothers company became world famous and supplied the glass optics for over four hundred lighthouses worldwide. Other famous names included Henry Lepaute and Sautter Harle in France and Wilhelm Weule in Germany. Today, the advance of materials technology has led to products such as acrylics and polycarbonates, which can replace

Above: A detail of the first order Fresnel lens, from the lighthouse at Langara Point, British Columbia, Canada.

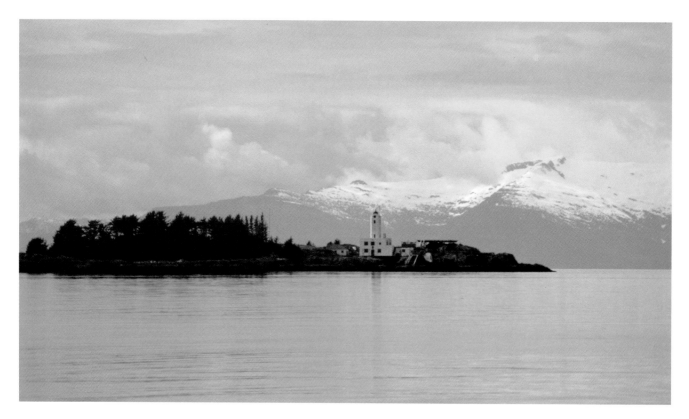

conventional glass in many applications and are lighter, more durable, and easier to produce in complex shapes than glass.

With the profusion of efficient maritime lights in the nineteenth century, it became imperative that sailors should be able to distinguish one light from another. If this could not be done then the resultant confusion could make the situation more hazardous than if the lights did not exist at all. A crude method was to vary the number of lights burned either by having more than one light tower as on the Casquet Rocks in the Channel Islands, or burning several lights from the same source. An example of the latter was the eighteenth-century Welsh lighthouse on the Mumbles, South Glamorgan, which had two braziers.

However, what was needed was some method whereby each light could be given an individual characteristic, and it was in Sweden that a mechanism capable of rotating the whole light was first installed. This was invented by the engineer Jonas Norberg and installed in a lighthouse at Carlsten on the west coast of Sweden. The machinery, consisting of a rotating mass carrying the light and its reflectors, was turned by a weight-driven mechanism to give the effect of a long flash when viewed from a distance. The idea of a revolving light

was quickly embraced by other countries, and the famous French light at Cordouan was so fitted in 1790.

Nevertheless, a number of other methods were also developed by engineers keen to make their mark, such as Robert Stevenson's clockwork-driven screens installed in some Scottish lighthouses around 1811. In this system, a series of screens were raised and lowered mechanically. However, the rotating mechanism was soon recognized to be the simplest and most reliable, and by careful design and grouping of the lights, a great variety of signals was possible..

Today, there are three major classifications of light signals, although combinations of these methods produce a number of subvarieties. The simplest is a fixed light that gives a constant illumination either visible from all directions or only from within a defined sector. The next is a flashing light in which a period of illumination occurs at regular intervals, but is shorter than the intervening period of darkness. Finally there are the an occulting light, in which a steady light is interrupted by short period of darkness (sometimes achieved by a screening mechanism rather than a rotating light), and the more complex Group Occulting, in which a steady light is interrupted by several periods of darkness. Variations on the flashing light include a fixed and

Above: Five Fingers, Frederick Sound, Alaska, US.

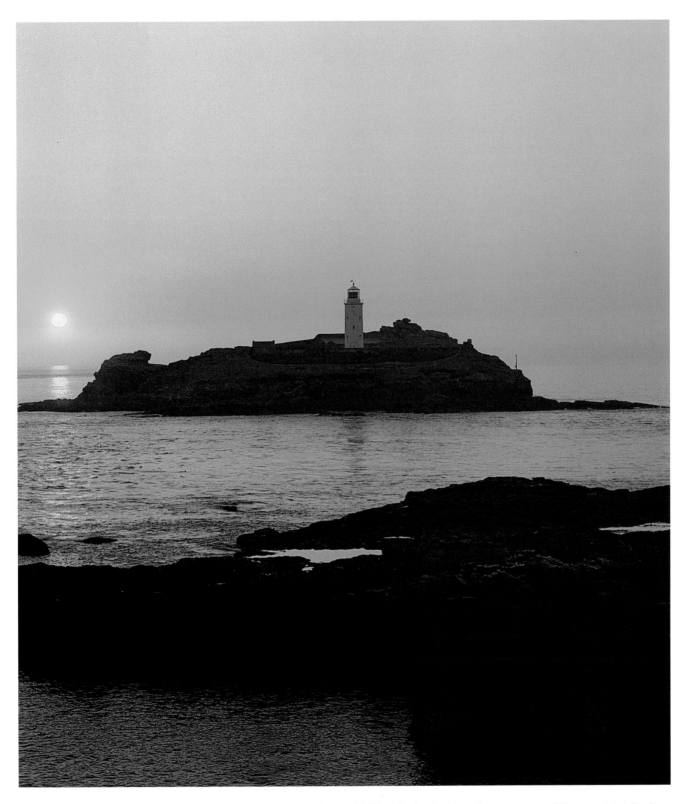

flashing light in which a fixed light is supplemented at intervals by a bright flash or flashes (Fixed and Group Flashing).

As well as varying the number of flashes, or occults, the timing may be varied in terms of period and rate of repetition. Thus, for example, the light at Start Point on the South Devon coast is categorized on charts as Fl(3) 10s, indicating that a group of three white flashes will be seen every ten seconds. Some fifteen miles (24.2 km) north is the Bolt Head light, classified as Fl(2) 15s, which indicates a double flash every fifteen seconds. A sailor making an uncertain landfall would quickly be able to identify these lights.

Above: Godrevy, Cornwall, Great Britain.

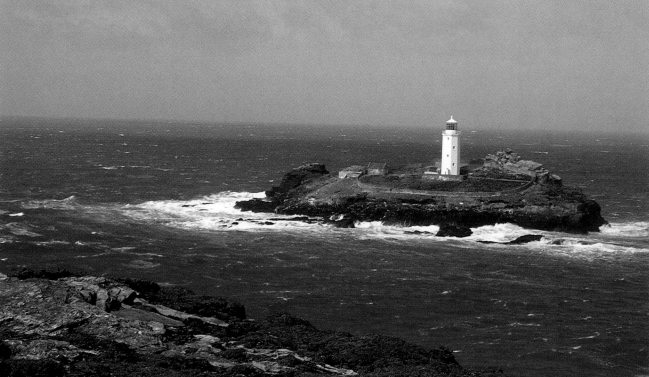

One other service that many lighthouses provided was an aural signal that could be heard in thick fog if the light was not visible. Initially devices such as gongs and bells were used, but these were later superseded by guns or other explosive devices, and later by sirens and air horns. The last type in common use were of the electromagnetic emitter type, which could be operated automatically or by remote control. Today, aural fog signals have fallen into disuse, to be mostly replaced by the recent technology of electronic navigation aids.

Electronic navigation aids became increasingly common from around 1930 onward when radio beacons were installed in many lighthouses. The radio operator on a ship could tune into the beacon and by means of shipboard direction-finding apparatus, obtain the bearing of the transmission. By tuning into two or more beacons, he could easily plot an accurate position. Since then, electronic navigation aids have increased in sophistication and complexity, and ships can usually obtain an accurate and instantaneous position check at any time.

Nevertheless, lighthouses, by virtue of their purpose, are located on or close to dangerous coastlines and hazards, so it is still useful for mariners to be able to locate them quickly and easily. The internationally accepted system to meet this requirement is the Racon (radar beacon), which gives out an identifying signal on receipt of transmissions from a ship's radar. This is displayed on the ship's radar screen. Virtually all lighthouses, especially those located at critical points, are now equipped with Racons and, in many respects, these can be regarded as electronic substitutes for the traditional flashing light. However, there are numerous occasions when a sailor is glad of positive visual confirmation of his position and, of course, a light signal does not require any specific shipboard equipment. Consequently, the lighthouses of the world will shine out for the foreseeable future.

Above: Godrevy, Cornwall, Great Britain.

Above: Lighthouses control the marine pass at Le Palais, Belle Isle, France.

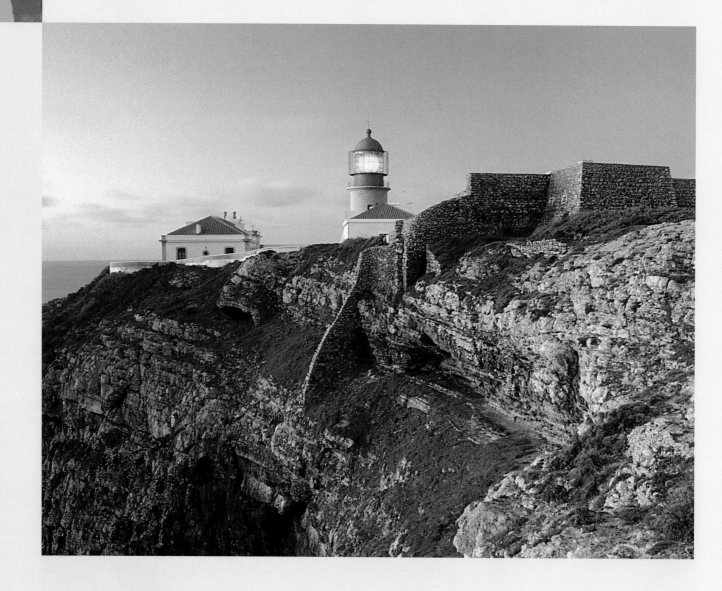

It was from the Old World that the great explorers such as Vasco da Gamma, Magellan, Columbus, Drake, and Cook set out to discover and explore the far corners of the world. In their footsteps trade rapidly followed and developed. Ships setting out from France, Spain, Portugal, and Britain sailed immediately into the Atlantic Ocean, often battling the prevailing westerly winds and beset by ferocious storms and gales. Even if they survived the rigors of their voyages to Africa, the Americas, and the Orient, their home-coming was perhaps the most hazardous part of the voyage, as they sailed back into European waters with its fickle weather and treacherous coastlines. It is not surprising, therefore, that many of the world's oldest and most famous lighthouses can be found along the western coasts of Spain, Portugal, France, and the British Isles.

In fact the world's oldest working lighthouse is here, at La Coruña on the northeast coast of Spain, and it has had checkered career. It was first erected by the Romans on the northwest side of a peninsula that provided shelter to the town and harbor. The original construction featured a large six-story square building surmounted by a cupola and a platform for burning fires in braziers. One of its most fascinating features was the fact that access was by means of a narrow external ramp carved into the walls—vertigo-inducing to say the least! Like many lighthouses of the period, it fell into disuse after the fall of the Roman Empire and stood neglected for many centuries, but in 1470 it was stripped of some of the outer masonry work, including the access ramp, in order to make it more useable as a defensive fort. It certainly came in handy as a place of refuge for the citizens of the town when

Above: Cabo Sao Vincente, Portugal.

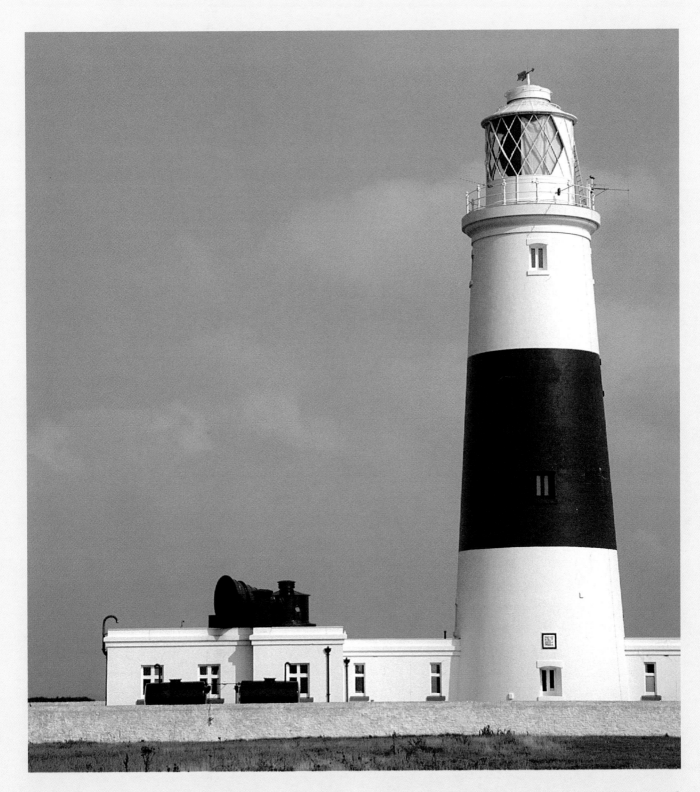

attacked, notably by Sir Francis Drake in the mid-sixteenth century.

However, the headland at Coruña was an important landfall for ships traversing the Bay of Biscay or approaching Europe from the Eastern Atlantic, so in 1682, as maritime trade increased, the English, Dutch, and Flemish consuls formally requested the Spanish authorities to re-establish a light for the benefit of all

passing seamen. This was done and a wooden internal staircase was fitted, but it was not until almost a century later that a major reconstruction was carried out under the supervision of a naval architect, Don Eustaquio Giannini. Sympathetic to the original Roman structure, he refaced the external masonry and strengthened the tower to support an additional twenty foot (6 m) octagonal tower upon which stood a

Above: Quenard Point, Channel Islands, Great Britain.

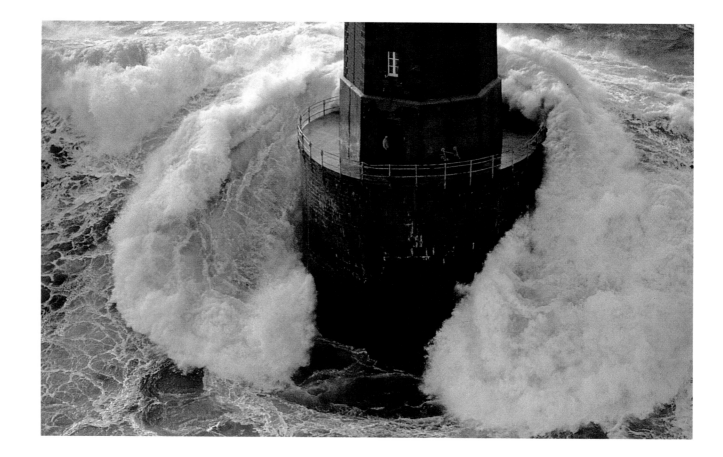

stone lantern containing the coal-fired brazier that vented through a chimney flue in the roof. This work was completed in 1791, and it is thought that the light from the fire was concentrated to some extent by a ring of twelve thick lenses that formed part of the lantern glazing. At some subsequent point the coal fire was replaced by an oil-burning lamp system, and by the mid-nineteenth century, there was a revolving light system which incorporated twenty-one reflectors and twelve convex lenses. This was housed in a taller and slimmer lantern house that had replaced the one built in 1791. The present light is electrically powered.

Although there were virtually no significant developments in the dark ages, one notable exception was the erection of a fire tower on the island of Cordouan in the seventh century. This was done at the instigation of Louis the Pious, son of the great Charlemagne, and it marked the shoal-infested entrance to the Gironde river leading to the town of Bordeaux, which depended heavily on the export of wine for its prosperity. How long this first tower stood is not known but it is subsequently recorded that England's Black Prince caused a lighthouse, chapel, and other dwellings to be built on

Cordouan at the start of the fifteenth century. In an interesting insight into the practical problems of running a lighthouse, then or now, it is recorded that the keeper of the light, a hermit named Galfridus de Pesparra, applied to Henry IV of England to allow the dues payable to be doubled to cover the cost of upkeep and repairs. The request was granted, and de Pesparra was permitted to charge $4 from each merchant vessel leaving Bordeaux. For the period, this was quite a significant sum of money. These buildings lasted for almost two centuries before the light tower was condemned and a much grander replacement built from 1581 onwards. While this was being built, the small island at Cordouan began to erode rapidly and subsequently completely disappeared, leaving only the foundations of the lighthouse completely protected by a massive sea wall.

The new tower was built to the design of the French engineer and architect Louis de Foix, and the outcome formed the basis of what is today the world's most magnificent lighthouse. Having built a 135 foot (41 m) diameter circular foundation, he proceeded to erect four further levels, each of circular section with a

Above: La Jument Lighthouse, off the western coast of Brittany, France.

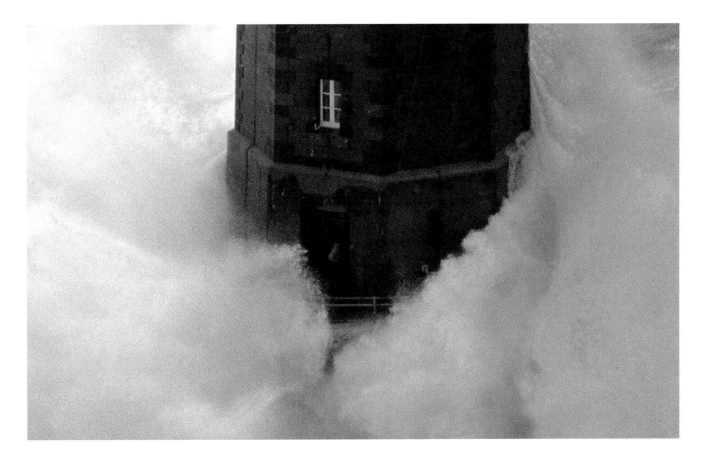

decreasing diameter. The lower story contained living quarters for the four lightkeepers, while the next floor was given over to sumptuous royal apartments intended for use by visiting royal personages (although the use of the structure as a place of refuge in time of war was also an important consideration). The third level was a chapel with a domed ceiling, and the fourth level contained a secondary lantern. The main coal-fired lantern was in a separate structure above the fourth level and incorporated a tall chimney to draw the smoke well away from the light. The whole building was fitted out in a grand and extravagant style with gilded woodwork, ornate carving, and stonework, and decorated with murals and mosaics. Naturally the creation of such a great structure was not to be rushed and its construction was spread over a period of twenty-seven years. The light was officially lit in October 1611 by the French monarch Henry IV. In this form Cordouan continued to mark the approaches to the Gironde estuary until the late eighteenth century when it underwent a substantial reconstruction.

This time the architect was Joseph Teulère who removed the existing lights above the chapel and built a substantial reinforced structure around and over the roof of the chapel. This formed the base for a new tower just under a hundred feet (29.5 m) tall, giving the whole structure a height of around 240 feet (67 m). It remains the world's tallest rock lighthouse. Of course, the French took great pride in this prominent structure, and it is interesting to note that it was declared a national historic monument along with the cathedral of Notre Dame in Paris in 1862. The light is still in use today, its occulting two-plus-one signal being visible from up to twenty-two nautical miles (25 miles; 40.2 km) away in daylight.

Some of the most dramatic French lighthouse engineering was off the rock-infested coast of Brittany, which is today well endowed with numerous lighthouses. One of the most famous of these is on a rock at the entrance to the Golfe de St. Malo on the south side of the Channel known as Heaux de Bréhat. Work on the site, which began in 1833, was constantly threatened by the weather and by the unpredictable surges of the tide that often trapped workers unexpectedly. It was another six years before a light shone out from the completed 155 foot (47 m) tower.

Above: La Jument, France. In this photograph the keeper can just be seen racing for the door as enormous waves engulf the lighthouse.

Next page: An aerial view of the lighthouse at Heaux de Bréhat, France.

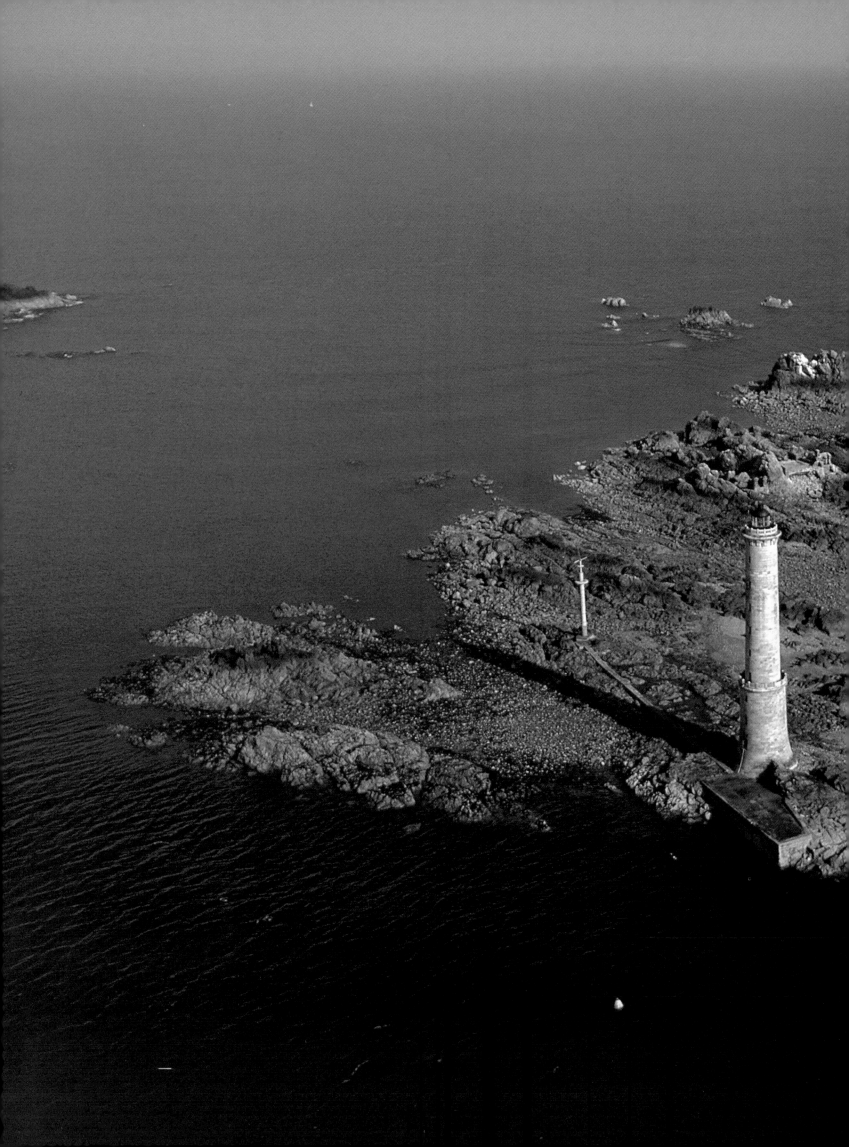

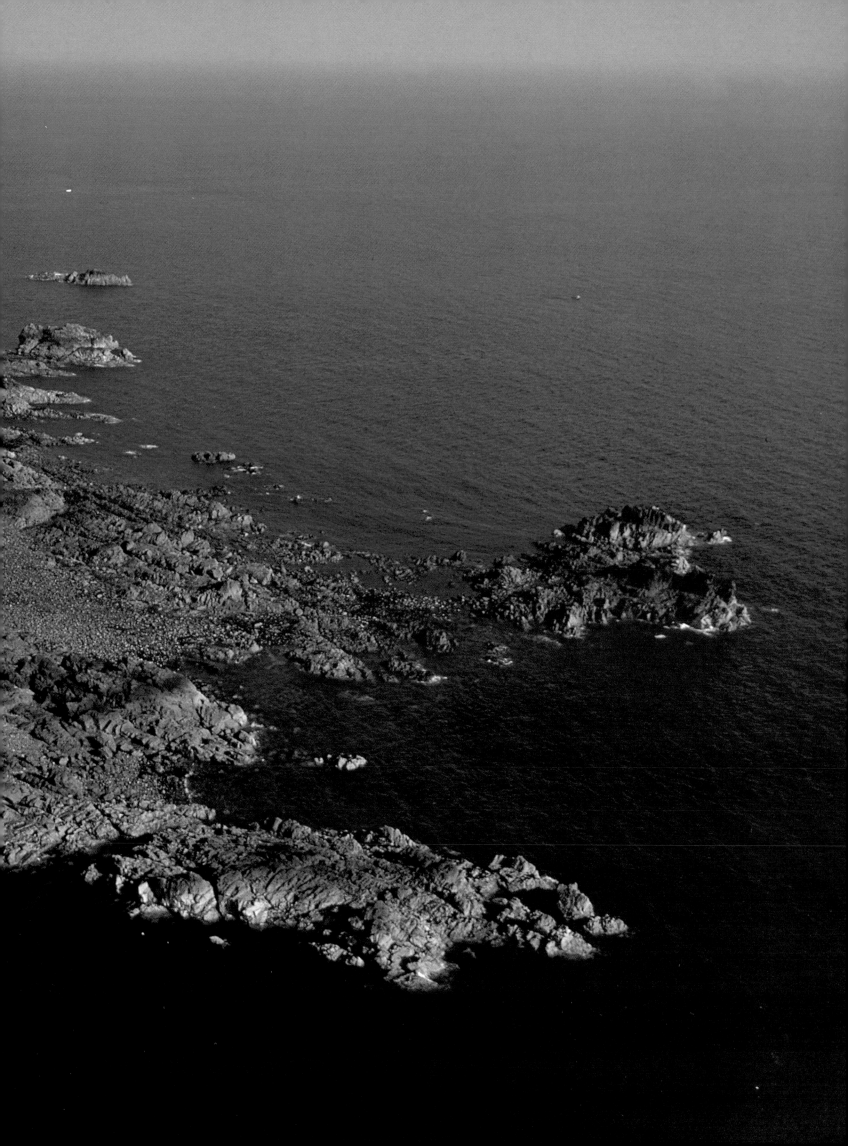

Another major building feat was at Ar-men near the Ile de Sein off the southwest tip of the Brest peninsula. Here a series of reefs runs at right angles to the prevailing tides and stirs up vicious currents and eddies, while mountainous seas can build in rough weather. Ar-men was a rock in the center of this area which projected only five feet (1.5 m) above the water at low tide. The difficulties of building a lighthouse here were tremendous. Nevertheless, the increase in seaborne traffic across the Bay of Biscay was accompanied by an unacceptable number of ships being lost on these rocks, so work eventually began in 1867. The work was abysmally slow, however, and in the first year it was only possible to land on the rock on seven occasions. In two years only twenty-six hours of work had been done. The engineers persisted, but it took nine years before the base of the lighthouse was completed and work on the actual tower could begin, this taking another five years. A first order light was eventually commissioned in 1881.

By the mid-nineteenth century, the methods of building rock lighthouses were well understood, but the

Above: The Tall Lighthouse, Harwich, Great Britain, which was built in 1818.

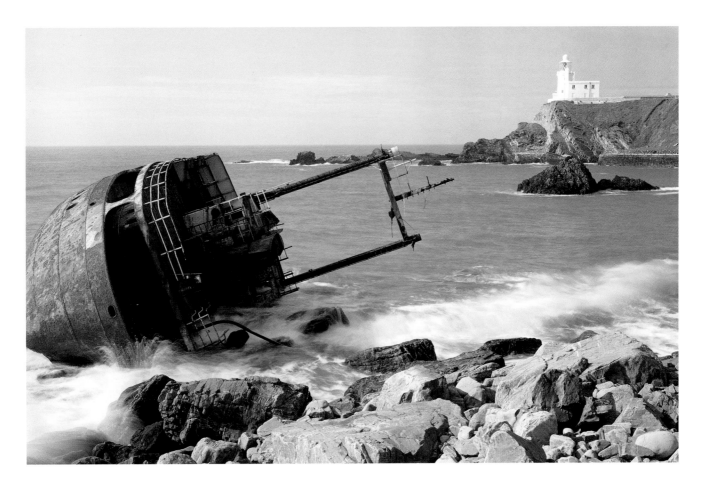

development of such techniques was inspired by the pioneering work of English engineers on the Eddystone lighthouses. This famous spot was the site of the first rock lighthouse in the world to be built in the open sea, and its story encapsulates the whole history of lighthouse development. The Eddystone is a dangerous group of rocks in the English Channel off the important port Plymouth on the Devonshire coast. It was, of course, from Plymouth that the Pilgrim Fathers had sailed in 1620 in the *Mayflower* at the start of their epic voyage to found a colony in the New World. At that time there was no light on the dangerous Eddystone rocks, just over ten miles (16 km) southwest of Plymouth, and right in the path of ships approaching the port from France and the Western Approaches. An unending toll of ships, together with their crews and cargoes, were lost on these rocks which were just covered at most states of the tide. The need for a lighthouse was obvious, although the technical problems of erecting one in such an inhospitable location seemed insurmountable, until a somewhat eccentric entrepreneur named Henry Winstanley determined to make the attempt after losing

two of his own ships on the Eddystone. His design was basically a wooden structure on a stone base and construction took over two years with the light being lit for the first time on November 14, 1698.

Apart from the obvious difficulties of combating the elements, Winstanley faced problems of another nature. England was at war with France at this time and such was the importance of the Eddystone project that the Admiralty provided Winstanley with a warship for protection on the days when work was taking place. However, one June morning in 1697, the British ship did not arrive—but in its stead a French privateer, which carried Winstanley off to France. When Louis XIV heard of the incident, he ordered that Winstanley be immediately released saying that "France was at war with England, not with humanity," illustrating that the importance of the Eddystone was recognized on both sides of the Channel.

Although the lighthouse survived its first winter, it suffered severe damage during the frequent gales and by the spring it was found to be badly in need of repair. Winstanley completely rebuilt his tower to a greatly

Above: The lighthouse at Hartland Point, Great Britain.

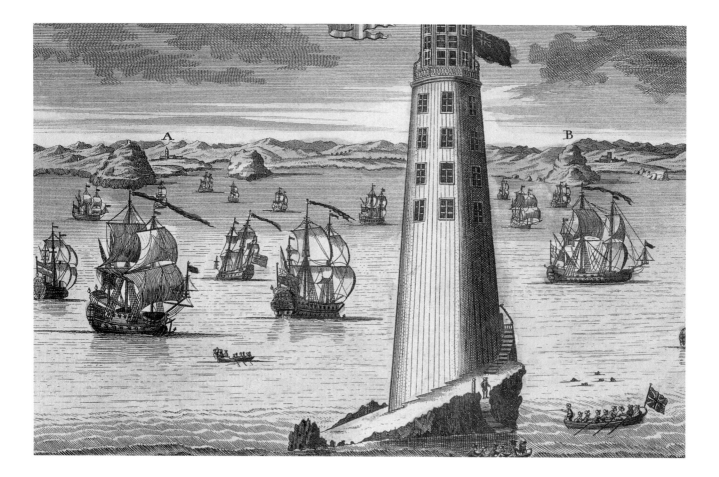

altered and strengthened design and included numerous features that exemplified his own eccentricity. When the work was finished in 1699, he expressed his confidence in the structure by stating that he wished he could be present in the lighthouse if it experienced the greatest storm that ever was. A strange twist of fate ensured that this wish was fulfilled almost to the letter. In November 1703, Winstanley had sailed to the lighthouse to supervise some repairs and that very night it was struck by a storm whose ferocity was the greatest recorded up to that time. When dawn broke over the restless wind lashed seas, there was no sign of the lighthouse or its occupants—it had been completely washed away by the seemingly all-powerful forces of nature.

Nevertheless, the brief five-year span of Winstanley's lighthouses had so improved the safety of ships sailing in that part of the channel that the need for a successor was apparent to all. A Captain Lovett acquired the lease of the Eddystone Rocks, which were owned by the Crown, and was awarded a patent charter to provide a light, being allowed to charge a toll of one penny per ton for each passing ship, whether it be inward or outward bound. In those times this represented a substantial income and provided the means for a third lighthouse to be erected.

This structure was completed in 1709. The designer, John Rudyerd, was strictly speaking an amateur, being a silk merchant by profession, but he obviously had a grasp of the problems involved in such structures and he adopted many techniques from contemporary shipbuilding practice to design and build a conical wooden tower. This was much stronger and taller than Winstanley's tower, which was of octagonal section, and it lasted for forty-seven years until it was destroyed by an accidental fire.

The lighthouse keeper on that fateful night of December 2, 1755, was one Henry Hall who was ninety-four years old but reputed to be fit and able. As he and a fellow keeper fought the fire, they threw buckets of water vainly upwards in an attempt to douse the flames. At one instant, as Henry Hall looked up, molten lead from the roof spattered the men and he swallowed a sizeable portion. Nevertheless he continued to fight the fire, but both men were gradually forced down onto the

Above: An engraving of Rudyerd's Tower, the third lighthouse built on Eddystone Rocks, in 1709, to prevent further shipwrecks in this notorious area of the English Channel.

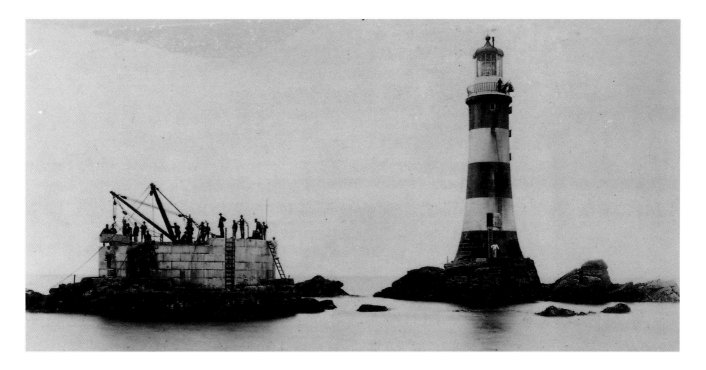

rocks as the fire spread inexorably downwards. Meanwhile the flames of the burning structure had been seen from land and a Mr. Edwards finally arrived in his boat of the Eddystone at ten o'clock the following morning. It was too rough to land on the rocks, but lines were passed to the keepers who were then hauled out to the waiting boat and taken to Plymouth. The fire took five days to burn itself out, completely destroying the lighthouse. In the meantime Henry Hall was fighting for his life, suffering from burns, exposure, and the lead he had swallowed. Nevertheless the gallant old man survived for twelve days before dying and at the post mortem, his physician, Doctor Spry, discovered a piece of lead weighing almost half a pound (approximately 250 g) in his stomach. Intrigued by this find, the doctor wrote an account for the Royal Society (the great scientific body of the time) but its members poured scorn on his account, refusing to believe that anyone could survive the ingestion of so much molten lead. Incensed by this rebuff, Doctor Spry subsequently carried out many experiments on dogs and other animals in which he poured molten lead into them to prove that they could live! Fortunately science has moved on today!

The destruction of Rudyerd's lighthouse was a serious matter, as Plymouth was by now a major naval port as well as a commercial center. As a temporary solution, a light vessel was placed near the Eddystone rocks while plans were drawn up to build a replacement. By this time the owner of the Eddystone lease was a Robert Weston who enlisted the help of the Royal Society to find a suitable person to design a build the new lighthouse. Their recommendation was a man called John Smeaton who was just completing a course of study under the sponsorship of the Christopher Wren Foundation and is generally recognized as Britain's first formally-qualified civil engineer. His design resulted in the classic lighthouse shape that has been copied and reproduced around the world. It is said that it was derived from the form of the oak tree with its sturdy and solid root supporting a tapering trunk. In practical terms, a solid foundation was built up on the rocks using local granite that also provided the facings to withstand the onslaught of the sea. Smeaton not only designed the lighthouse but invented materials and methods, such as quick-drying cement and lifting gear for the heavy granite blocks, which have stood the test of time and are still used today. However the key to the success of his structure lay in the method of dovetailing the blocks of granite and securing them with marble dowels. This set the method for lighthouse construction for the next 150 years. The actual construction called for the toughest of men, and a ready source of labor was provided by tin miners from Cornwall. However, in those times, any able-bodied man ashore was liable to

Above: Eddystone, 1880, with the new lighthouse being constructed alongside.

be rounded up by the notorious press gangs and sent unwillingly to sea aboard one of the Royal Navy's warships. Fortunately the Admiralty was as keen as anyone to see the light rebuilt and Trinity House arranged to have each man issued with a specially struck medal which would exempt him from naval service. Needless to say, these medals were highly sought after!

Completed in 1759, the light was first activated on October 16 of that year, illumination being provided by twenty-four candles. Smeaton's granite edifice subsequently withstood the ravishes of the sea for over one hundred years and was only defeated when the rocks on which it stood began to erode and the need for a replacement became apparent.

By that point responsibility for the Eddystone lighthouses had passed to Trinity House, and they commissioned the Engineer-in-Chief, James Nicholas Douglass, to supervise the design and construction of the fifth lighthouse on this site. Douglass was steeped in lighthouse lore, his father having been responsible for the construction of many lighthouses, including the Bishop Rock light on the Isles of Scilly, and he had held his Trinity House appointment since 1863. He began work on the new Eddystone light in 1877. It was completed some five years later, officially opened by the Duke of Edinburgh who ceremonially laid the last stone. Douglass had improved on Smeaton's technique of dovetailing stones. The rings of granite blocks making up each layer of the tower were not only locked together in this way but were also locked to the layers above and below. This made a fantastically strong structure that still stands today. Once it had been completed, work began on dismantling the upper part of Smeaton's tower, which had stood for 123 years, and this was carefully re-erected and restored on Plymouth Hoe where it now stands as a prominent landmark in the city and is regularly open for public viewing.

The present Eddystone light continued the tradition of pioneering work on the Eddystone site when it became the first Trinity House rock lighthouse to be automated. This work, which also entailed the construction of a helicopter landing platform above the lantern, was completed in May 1982 which, amazingly,

was exactly one hundred years to the day after the lighthouse first opened. This modernization spelled the beginning of the end for manned offshore lighthouses and the Eddystone, along with many others, is now controlled from the Trinity House Operations Control Centre at Harwich in Essex.

The success and obvious usefulness of the Eddystone light gave the impetus to provide lights in other locations previously thought untenable for a man-made structure. Perhaps the most dramatic of these was the rock ledge known as Bishop Rock some four miles (6.4 km) west of the Scilly Isles, the south-westerly extreme of the British Isles. These rise almost vertically from the sea floor over a hundred feet (33.3 m) below and are exposed to the full force of the Atlantic Ocean. These dangerous rocks caused the wreck of many ships over the years, most famously that of Sir Cloudesley Shovel's squadron of the Royal Navy in 1703 in which 2,000 men died. The Elder Brethren of Trinity House decided that the old lighthouse at St. Agnes, actually on one of the islands, was totally inadequate and looked at the Bishop Rock itself, entrusting the formidable task to its Engineer-in-Chief, James Walker. His original plan envisaged a screw pile structure that, it was hoped, would offer less resistance to the waves. Work began in 1847. A storm on the evening of February 5, 1850, swept the almost completed structure away, and a new design was prepared, based on Smeaton's work at the Eddystone. The relatively small size of the rock gave little space for solid foundations, but a 33 foot (10 m) base was eventually prepared, although much of it was actually constructed below the low-water mark. The inhospitable working conditions, coupled with frequent and prolonged spells of bad weather, meant that it took seven years to complete and the light was not illuminated until September 1, 1858. Even then, it was battered mercilessly by the elements, including one occasion when a wave washed right up the 114 foot (35 m) tower and tore away a fog bell weighing a quarter of a ton! When Sir James Douglass inspected the tower in 1881, he reported extensive damage and proposed a substantial reinforcement that effectively meant building a new tower

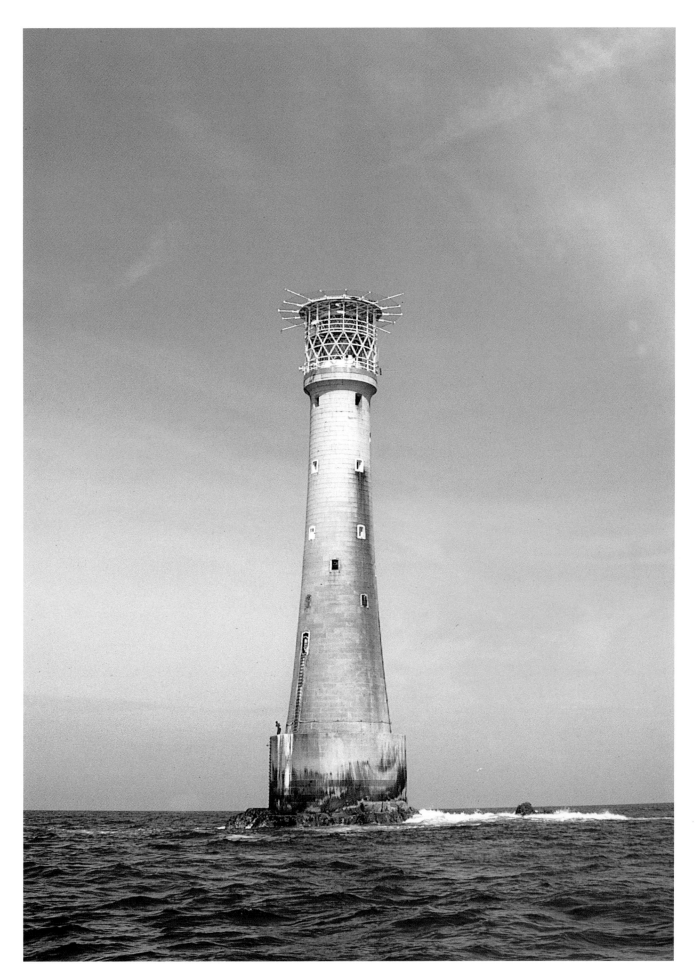

Above: Bishop Rock, Scilly Isles, Great Britain.

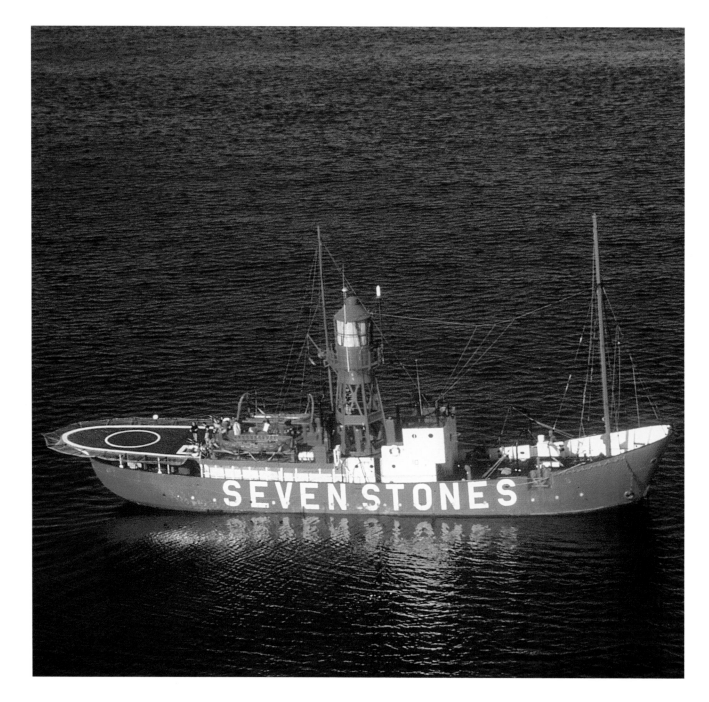

Above: The Seven Stones Lightship, off the Cornish coast, Great Britain.

around the old one. In the course of this work, the mass of the building rose from 2,500 tons to 5,700 tons and its overall height increased to 154 feet (47 m).

The new light was commissioned in October 1887. The original light had been provided by a vaporized paraffin burner, and this system was retained by Douglass. In fact it was not converted to electric power until 1973, after which modernization continued apace with the construction of a helicopter platform above the lantern in 1973. This made the relieving of the keepers and the provision of supplies independent of sea conditions, although the helicopter would still be

subject to wind speed limitations. Finally, Bishop Rock was converted to automatic operation during 1991, and the last permanent keepers left the lighthouse on December 21, 1992.

To the east of the Scillies was another rock outcrop, dangerously positioned in the middle of the passage between the islands and the mainland at Lands End. This area was known as Wolf Rock because of the eerie howl created when strong winds blew through the fissures in the rock and because of its fancied resemblance to the shape of the eponymous animal's head. The sound of the wind in the rock could be heard by

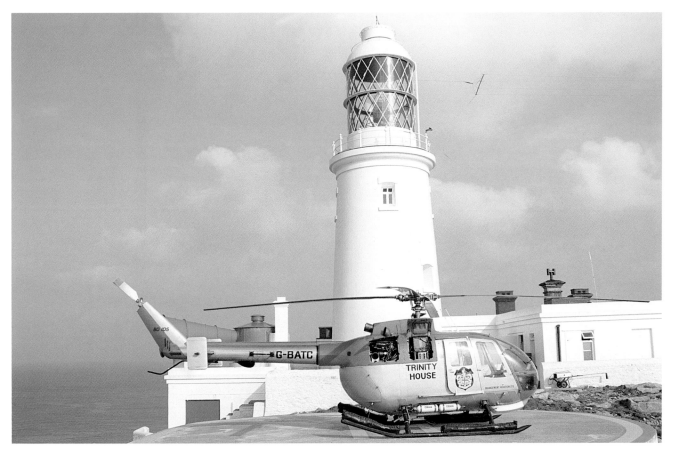

vessels in the area and it acted as a natural warning. This was a distinct disadvantage, however, as far as the local Cornish wreckers were concerned, and so they filled the cracks with boulders in an attempt to silence the noise so that more macabre trade would come their way.

The first proposal for a light to mark this well-known hazard came from a Lieutenant Henry Smith, who obtained the lease of the rock in 1791 but was unable to overcome the difficulties of building a permanent lighthouse. Instead he erected daymark consisting of a wrought iron mast about twenty feet (6 m) high and four inches (10 cm) in diameter, supported by six stays and surmounted by a metal model of a wolf on the rock. This insubstantial structure stood little chance against the forces of the Atlantic Ocean and it was soon washed away. The designer himself eventually fared little better, ending up in Fleet prison after various other forays into lighthouse ventures!

A more substantial marker beacon was erected between 1836 and 1840 by a Scottish engineer, James Walker, who was a prolific lighthouse builder and was later to build the Bishop Rock lighthouse already

described. His beacon on Wolf Rock survives in part to this day, but it did not provide enough of a warning to ships and in 1861 work began on the construction of a new granite lighthouse to Walker's design. This closely followed the shape and form developed by Smeaton at the Eddystone but with detailed improvement to the masonry joints so that the sea was unable to wash directly into the cement and mortar. The work was painfully slow initially, but in 1864 a landing stage was completed which allowed the easier transfer of materials. Still the structure was not completed until July 1869 and a permanent light was not established until the following year. The original oil-fired light was replaced by electricity in 1955, and in the early 1970s, Wolf Rock was the first rock lighthouse in the world to be fitted with a permanent helicopter landing pad. It was fully automated in 1988, and like most other British offshore lighthouses, it is controlled from the Trinity House Operations Centre at Harwich.

Another rock strewn peninsula presenting a danger to regular shipping routes was the southwest tip of Wales and this was eventually marked by several lighthouses including those at St. Ann's Head, Skokholm,

Above: The Trinity House service helicopter at the Round Island lighthouse in the Scilly Isles, Great Britain.

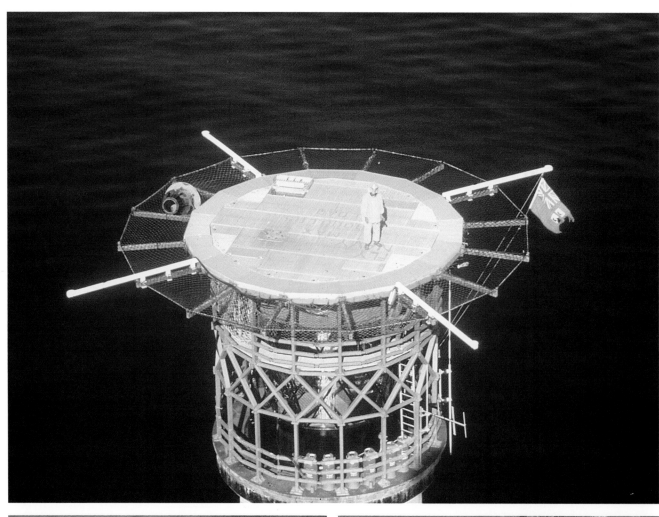

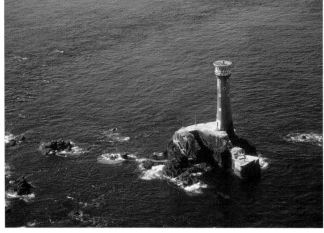

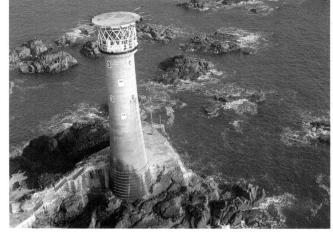

South Bishop, and Strumble Head. Perhaps the most famous is that on the Smalls, a reef of rocky islets some eighteen miles (29 km) off the coast. The present lighthouse was designed by James Walker, but the construction was supervised by James Douglass when work began on assembling and preparing materials at the end of 1855. Preliminary work on the rocks began the following year and the light was in service on August 7,

1861, some two months ahead of schedule. Like Wolf Rock, a helideck was added (in 1978) and the light was fully automated some ten years later.

This was not the first lighthouse on the Smalls, however. The original was designed and built on the instructions of the Smalls' leaseholder John Phillips by one Henry Whiteside—who was actually a musical instrument maker from Liverpool! In contrast to the

Top: Wolf Rock, Cornwall, Great Britain.

Above, left and right: Longships Lighthouse in Cornwall, Great Britain.

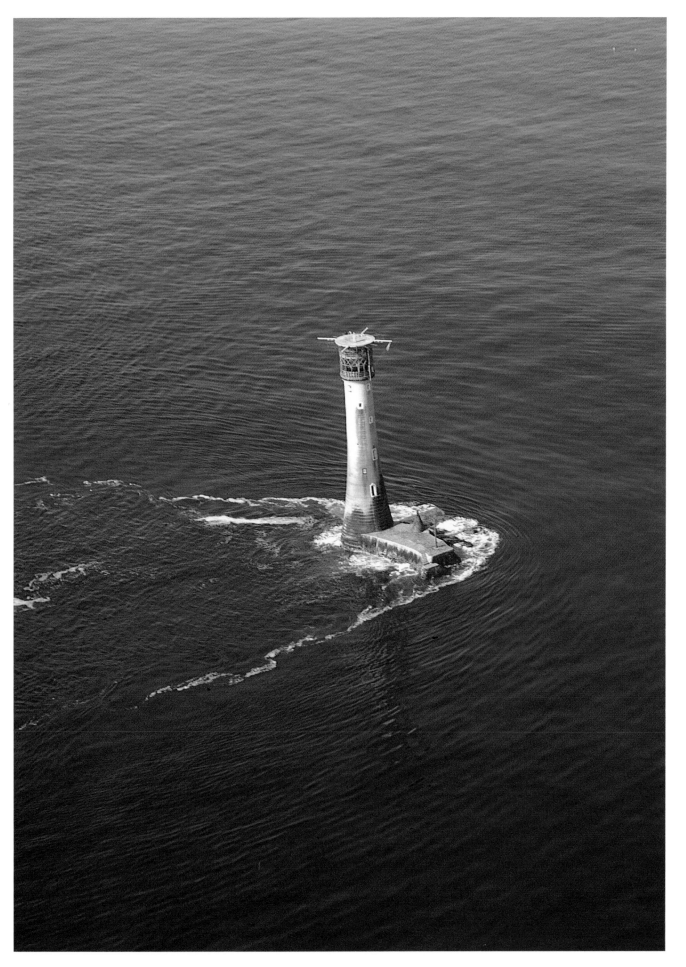

Above: Wolf Rock, Cornwall, Great Britain.

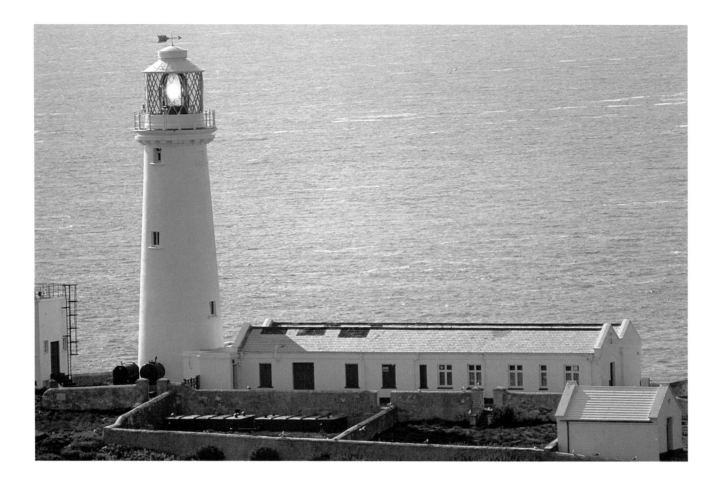

later stone structure, his lantern was housed in an octagonal timber housing on a central timber post and supported by five wooden and three cast-iron angled pillars. After a trial assembly ashore, the whole structure was dismantled and reassembled on the Smalls in 1776, the light being commissioned in September of that year. The use of partial iron pillars was not a success and these needed to be replaced by elm or oak posts within a year, but thereafter, this unlikely structure survived into the nineteenth century and was replaced by Douglass' tower in 1861.

At the beginning of the nineteenth century, Douglass' tower was the setting for one of the most macabre stories associated with any lighthouse. Toward the end of 1801, one of the two keepers, Thomas Girth, became seriously ill and died within three weeks of landing on the rock. The other keeper, Thomas Howell, was unable to communicate with the shore or passing ships and in an attempt to signal his plight, he built a coffin for the dead man and hoisted it to hang alongside the lantern. Although several passing ships reported the presence of a strange object hanging from the

lighthouse, they did not realize its significance, and as Howell stolidly fulfilled his duties and kept the light burning, nobody realized anything was wrong. For various reasons, including the harsh winter weather, the routine relief for the keepers did not arrive until more than three months later, in the spring of 1802. By this time Howell was near death himself from starvation and was badly affected by the trauma of the situation, having daily lived alongside the coffin that contained the decomposing body of his friend and colleague hanging in full view. He never worked in the lighthouse service again. As a result of the sad case, Trinity House introduced a rule that the minimum staff on isolated rock lighthouses should be three men.

Along the south coast of Britain are a number of lighthouses lighting the way for ships making their way up the English Channel. Some of these have very ancient backgrounds such as the one on Portland Bill, a prominent headland beset with dangerous currents at certain states of the tide. These hazards were recognized as far back as Roman times when fires and beacons were sometimes lit on the hill above the Bill,

Above: South Stack, Holy Isle, Wales, Great Britain.

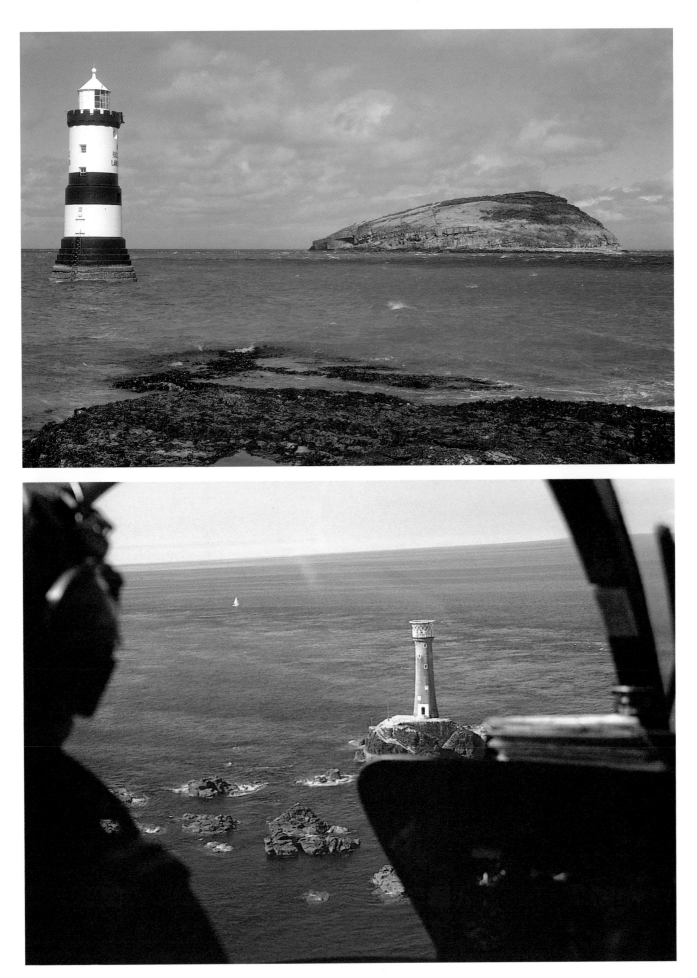

Top: Penmon Lighthouse, Puffin Island, Wales, Great Britain.

Above: Longships in Cornwall seen from the Trinity House service helicopter.

Above: La Corbiere, Channel Islands, Great Britain, 1890.

but it was not until the early eighteenth century that any attempt was made to provide a permanent light. Two private businessmen obtained a licence from Trinity House to erect a lighthouse and collect dues from passing ships. The lighthouse was first lit in 1716 and by 1740 it was bringing in a profit of £1,000 annually—a very tidy sum for those days. However Trinity House were not happy with this arrangement, and when they were able to confirm that the light was not being regularly lit and maintained as was required under the terms of the licence, they were able to use this as an excuse to take control. In 1788 they built a new sixty-three foot-(19 m) high lighthouse lower down the cliff but retained the older structure and used both to test various developments in light technology, including the newly invented Argand oil lamps and a lens system

developed by an Englishman, Thomas Rogers. Over the years both towers were regularly improved, and additional accommodation for the keepers was provided in 1856, but by the end of the nineteenth century they were showing their age. A completely new 115 foot (35 m) stone tower was built between 1903 and 1905 to house a 2.5 million-candlepower oil light built by Chance and Co., the famous Birmingham-based optics manufacturer. This tower is still in use today although the light is now electric.

Further along the coast is a lighthouse nestling just below the cliffs at Beachy Head, creating a spectacular image against the 300 foot (91 m) high white chalk cliffs. A light was lit here as early as 1670, but in 1828 James Walker erected Belle Toute Lighthouse, a fifty foot (14 m) circular tower, on the headland. This

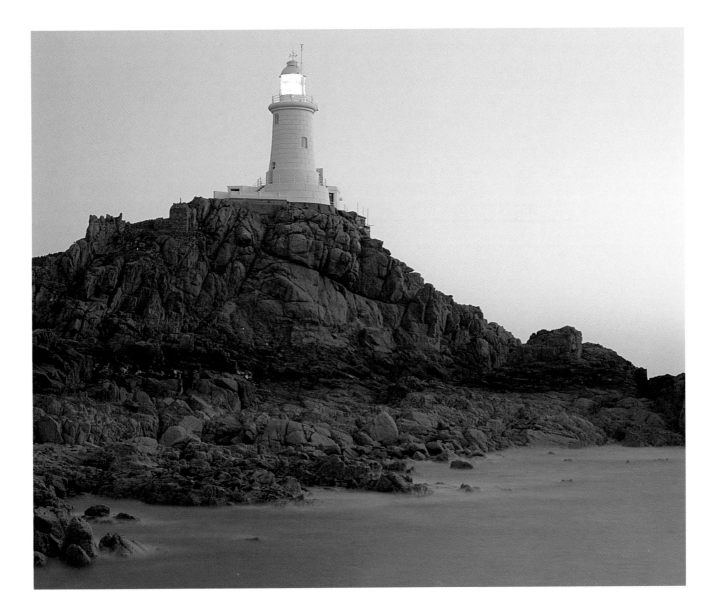

remained in operation till 1899 when it was abandoned because it was frequently shrouded in mist and threatened with collapse due to the gradual erosion of the cliffs. In 1902, under the direction of Sir Thomas Matthews, the Trinity House Engineer-in-Chief, the present lighthouse was completed as a replacement. Some 500 yards (455 m) offshore, the lighthouse took two years to complete and involved building a cofferdam and a cableway from the top of the cliffs to carry materials down to the site. Over 3,000 tons of Cornish granite were used in its construction.

Today, as with all other major lights in Britain, Beachy Head lighthouse is unmanned and fully automated. However, the old lighthouse was sold and taken over as a private residence despite the dangers of it one day collapsing into the sea. By 1999 this danger had become acute and the building was only a few yards from the edge of the very unstable cliff. It was thought that the next major slippage would carry the building away, so an ambitious scheme was put into operation to move the entire building inland by about 164 feet (50 m). This was done by carefully excavating around the foundations and moving it along a specially constructed track. The whole operation was successfully completed in March 1999.

Further east is the massive shingle bank at Dungeness, an important landmark on the passage up channel. The first serious attempt at providing a light here was by a Sir Edward Howard who, under a Royal patent, caused a fire to be lit on the point and collected dues from ships from around 1615. However he turned over his rights to one William Lamplough, who over a

Above: La Corbiere at dusk, Channel Islands, Great Britain.

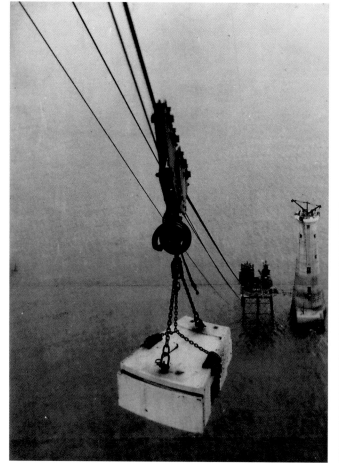
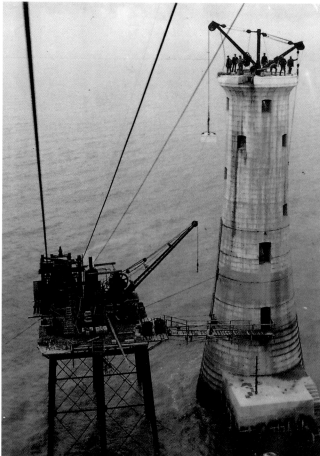

period of time built and maintained two coal-fired light towers. One of the problems with Dungeness was that the sand and shingle headland was constantly being enlarged by the action of the sea, and the light towers gradually receded from the shoreline. By the end of the eighteenth century, the need for a new tower arose. The new structure, although built on land, was to the same design as Smeaton's handsome tower on the Eddystone and was completed in 1792. It was 115 feet (35 m) high and the light source was provided by eighteen sperm-oil lamps, which by 1802 were improved by the use of specially designed parabolic reflectors. In 1862 Dungeness was one of the first lighthouses to be provided with an electric light; however, the technology of the time was such that it was subsequently replaced by a more reliable oil lantern.

By 1901, the shifting coastline again necessitated a new lighthouse, and the so-called High Tower was completed in 1904. This was a wide brick built structure rising 134 feet (41 m) above the ground and, when finished, the older tower was demolished. By the 1960s

even this new tower was set back over 500 yards (455 m) from the water, and the construction of a huge nuclear power station nearby obscured the light from some directions. So yet another tower was built, although this was a modern concrete structure completed in 1961 and one of the first to be equipped with a xenon electric arc lamp as the source of illumination. The tower is painted in conspicuous black and white bands and is floodlit at night to assist identification. The paint has an interesting side effect. For reasons still not fully understood, Dungeness has always been an important way station used by millions of birds in their annual migrations. The lighthouses here have always been something of an obstruction and each year thousands of birds were killed when they accidentally flew into the towers at night. Since the new tower has been floodlit, the number of avian mortalities has dramatically decreased.

Continuing around the British Isles, the East Coast looking out onto the North Sea is lit by a chain of lighthouses including, among many others, North Foreland,

Above: These pictures show the last stone being placed on Beachy Head lighthouse, Great Britain, in 1902.

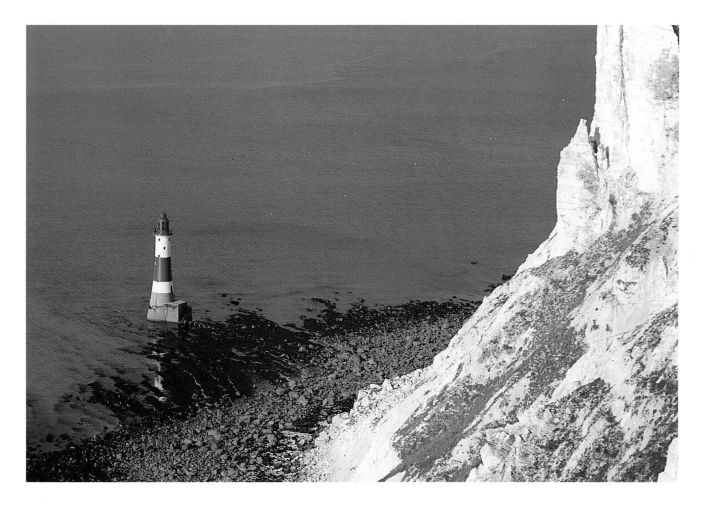

Orfordness, Spurn Head, Flamborough Head, Coquet Island, and St. Abbs Head right up to the Firth of Forth and beyond. Perhaps the most famous of these is situated on a group of rocky islands off the Northumbrian coast. Situated right in the middle of the natural offshore coastal route, the Farne Islands have had a lighthouse of sorts since 1778, although various attempts had been made before then. For example, in 1673, Sir John Clayton erected a tower on the Farne Island, but the Newcastle merchants refused to pay him any dues for its upkeep and the fire was never lit. At last, in 1778 two wooden towers were erected, but one of these was blown down in a storm in 1784 and, although replaced, by the start of the nineteenth century both were in urgent need of repair. Consequently, in 1809 Trinity House took over responsibility for providing a lighthouse on the Farne Islands and a fine new tower was completed in 1811 to the design of Daniel Alexander. Although only forty-three feet (13 m) high, it was a strong and purposeful structure which remains in use today. Other small towers were built on some of the other islands, and cottages were erected for the lighthouse keepers and their families.

It was not because of any attributes of the lighthouse itself that the Farne Islands became famous overnight, however, but as a result of a stirring incident on the night of September 6, 1838. At that time the keeper was William Darling, and he lived on the Farne islet of Longstones with his wife and twenty-two year old daughter, Grace. On that particular evening a great storm drove the paddle steamer *Forfarshire* onto the Big Harker Rock and it sank almost immediately, leaving only thirteen frightened survivors clinging to the rock. Four of these did not survive the night. In the morning the remainder were spotted by Grace, who roused her father. They immediately launched their cobble, a small but tough rowing boat built in the local style, and made their way across the wave-lashed sea to the rocks. While Grace skillfully took the oars and held the boat just off the rock, her father leaped across and then helped five of the survivors into the boat. They landed safely back on the Longstones, and her father

Above: Beachy Head as it stands today.

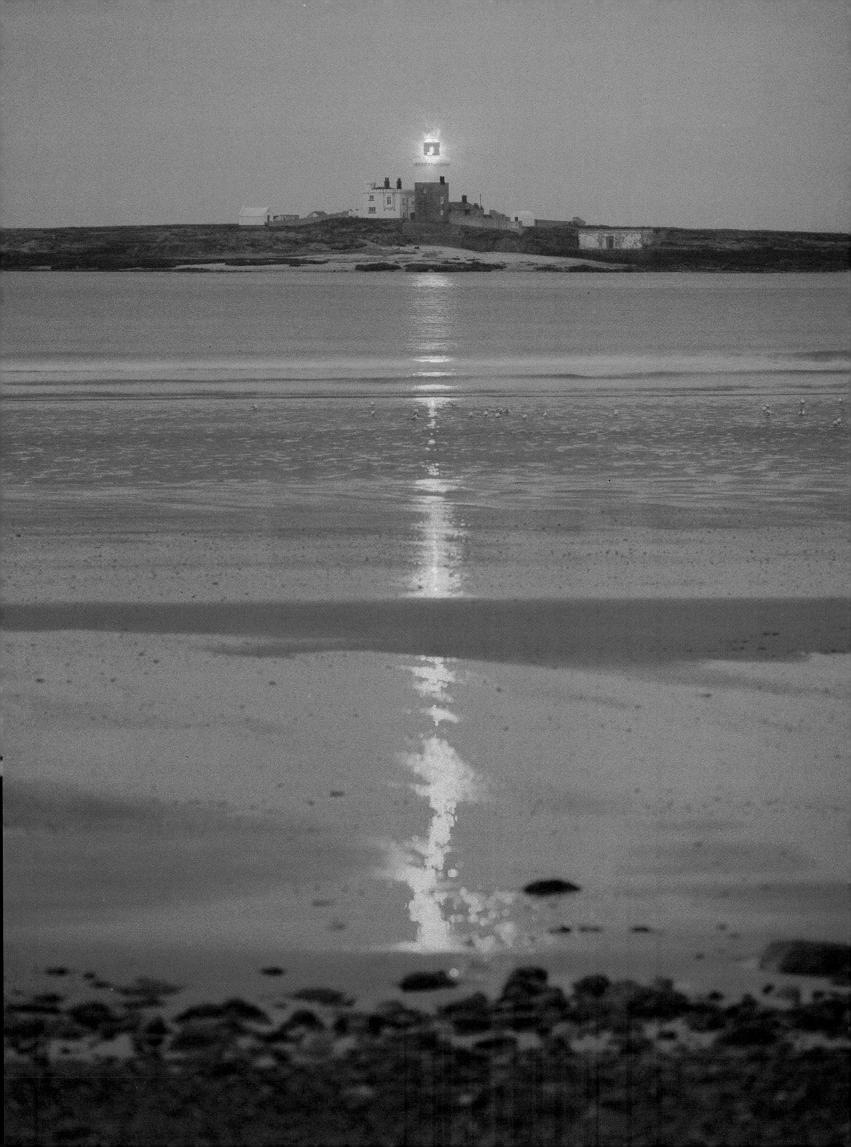

and two of the survivors then returned to pick up the others. Overnight, and quite rightly, the shy retiring girl became a national hero and even went to London to be introduced to Queen Victoria. She disliked the publicity, though, and regrettably died of consumption a few years later at the age of twenty-six.

Further north, the Scottish coast is ringed by many fine lighthouses, some built in the most difficult spots. One of these, Britain's most northerly light, is on the rocky crag of Muckle Flugger, just off the extremity of North Unst in the Shetlands. Muckle Flugger rises vertically out of the water to a height of 196 foot (59.5 m) above the high tide mark, posing serious problems to the construction workers who had to be mountaineers even to reach the site in the first place. Nevertheless a lighthouse was built here in the record time of only twenty-six days in 1854. The reason for the haste was that Britain was at war with Russia and although the battles were actually fought in the Crimea, there was an ever present danger of incursions by the Russian fleet. Consequently, the Royal Navy set up a system of patrols around the north coasts. It was to assist these ships that the Muckle Flugger light was built. The original temporary structure was replaced a year or two later by a stone tower, and this stands a total of 260 foot (78.8 m) above sea level. Nevertheless, the storms in this area are so severe that even this tower can be washed by waves which drive up the side of the crag!

The lighthouses of Scotland (and the Isle of Man) are administered by the Commissioners of the Northern Lights, a separate body from Trinity House which is responsible for lights in England and Wales. Across the Irish Sea, the lights of Ireland are the responsibility of yet another body, the Commissioners of Irish Lights. One of their most interesting lighthouses, and one of the world's most modern, is at Kish Bank in Dublin Bay. This sandbank was a serious hazard to ships navigating into the harbor at Ireland's capital city and had been

Above: The lighthouse at Southwold, Suffolk, Great Britain.

Left: Coquet Island, Northumberland, Great Britain.

marked since 1811 by a lightship. There was an unsuccessful attempt to build a screw pile lighthouse in 1842, but it was not until 1965 that a permanent lighthouse was established. This was built on the reinforced concrete caisson principle, and it was assembled ashore by and towed out into position in June 1965 and sunk in a depth of fifty-two feet (16 m) of water. The concentric center sections were then floated and jacked into position, and the center space filled with ballast. The new tower stands some 108 feet (33 m) above the water and is topped by a wide helicopter landing platform.

A much older Irish lighthouse is on the Old Head of Kinsale on the south coast near Cork. One of the earliest lights here was in the form of a cottage lighthouse, a form unique to Ireland in which a specially designed cottage would be built on a prominent headland with a hearth for a fire or brazier on the roof. One was present on the Old Head at Kinsale from the early eighteenth century, but the present imposing tower was built in 1853 by George Halpin, who was the son of another famous lighthouse builder and who was also responsible for the nearby Fastnet Rock lighthouse. Together, father and son built over fifty Irish lighthouses.

The father, also named George, was responsible for the Tuskar Rock lighthouse off the southeast tip of Ireland at the entrance to the St. Georges Channel between Ireland and Wales. This took several years to build and was completed in 1815. In October 1813, during its construction, 14 lives were lost when a huge wave washed over the temporary wooden quarters used by the builders and washed it into the sea. There were only ten survivors who clung to the rock for two days

Above: Lighthouse at the southern tip of Lismore in the Firth of Lorn, Strathclyde, Scotland.

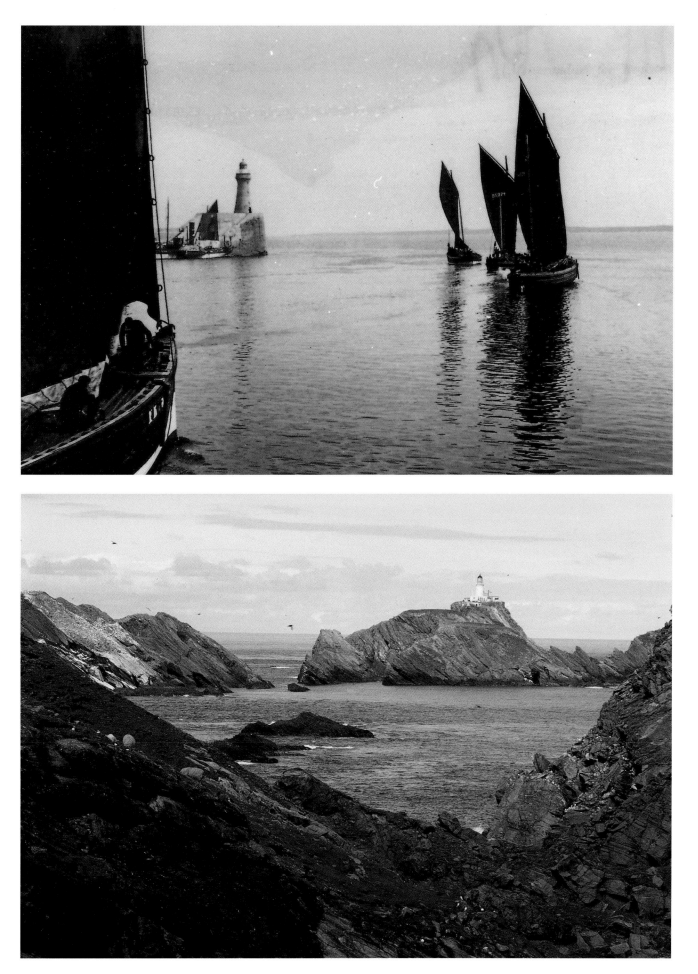

Top: Herring boats around Fraserburgh, Scotland, 1899

Above: Muckle Flugger, Scotland.

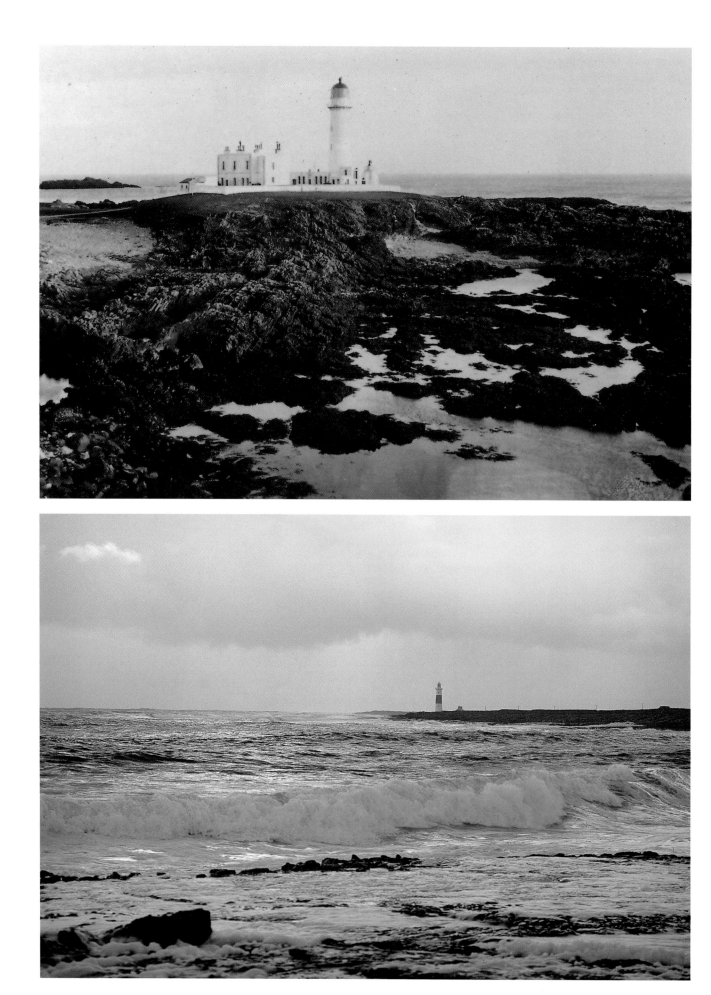

Top: The South Lighthouse at Fair Isle, Great Britain.

Above: South Island, Inisheer, County Galway, Ireland.

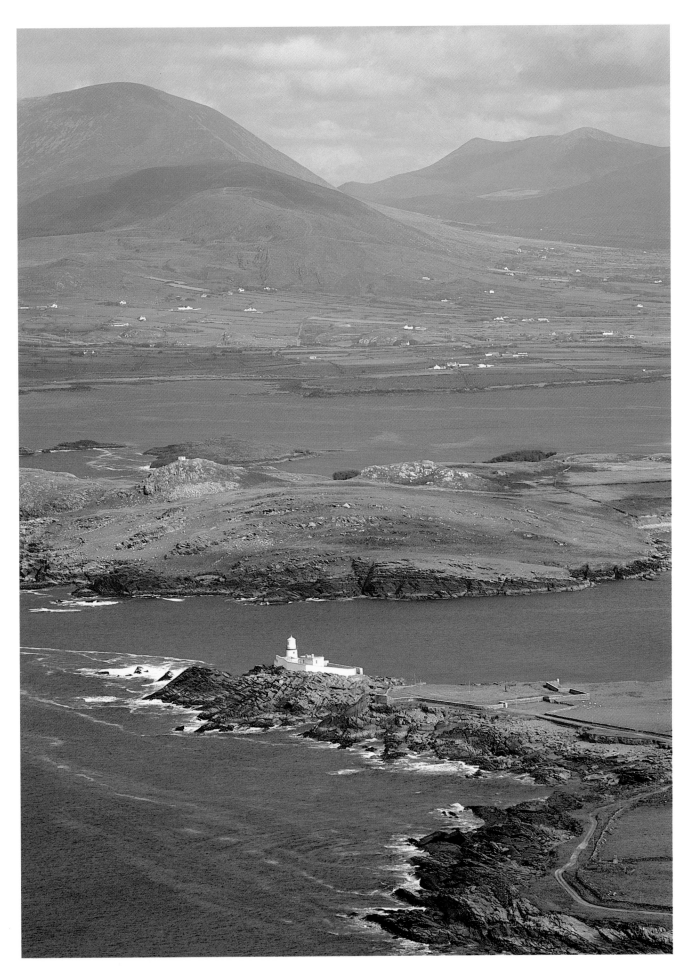

Above: A view across the lighthouse on Fort Point, Valencia, County Kerry, Ireland.

Next page: An aerial view of Fort Point, Valencia, County Kerry, Ireland.

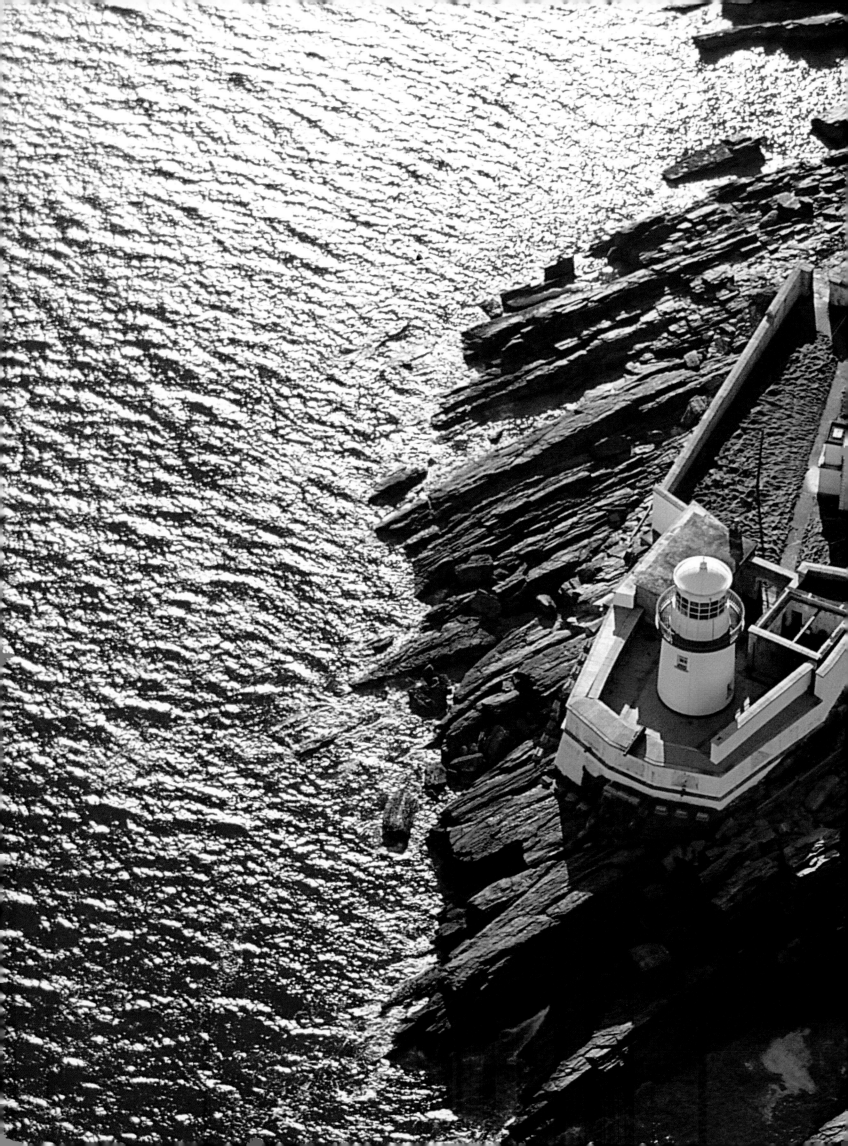

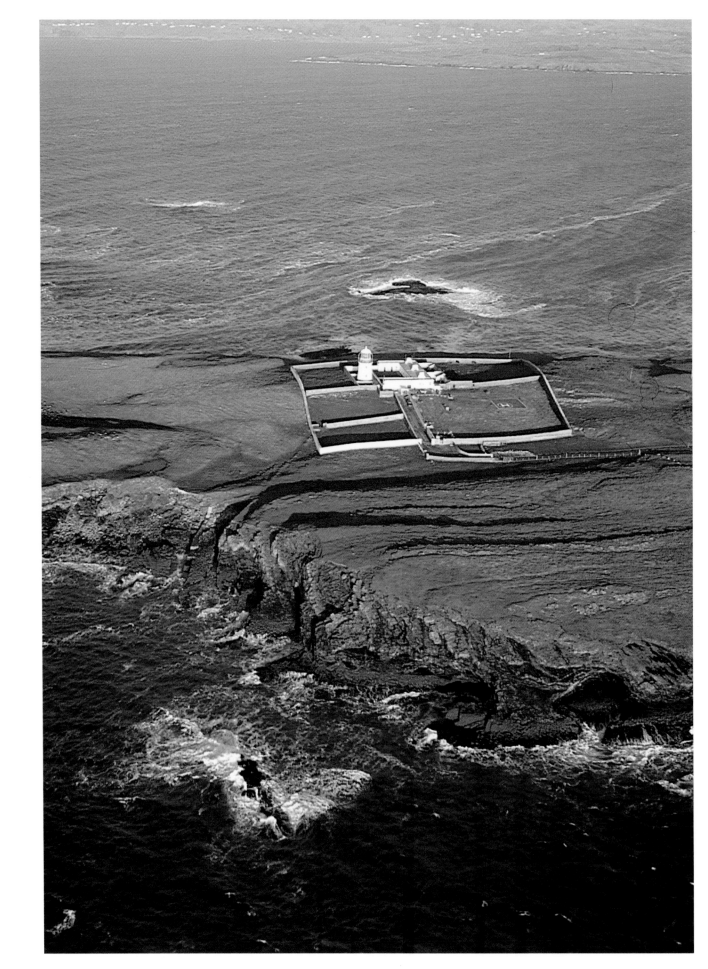

Above: The lighthouse at St. John's Point, County Donegal, Ireland.

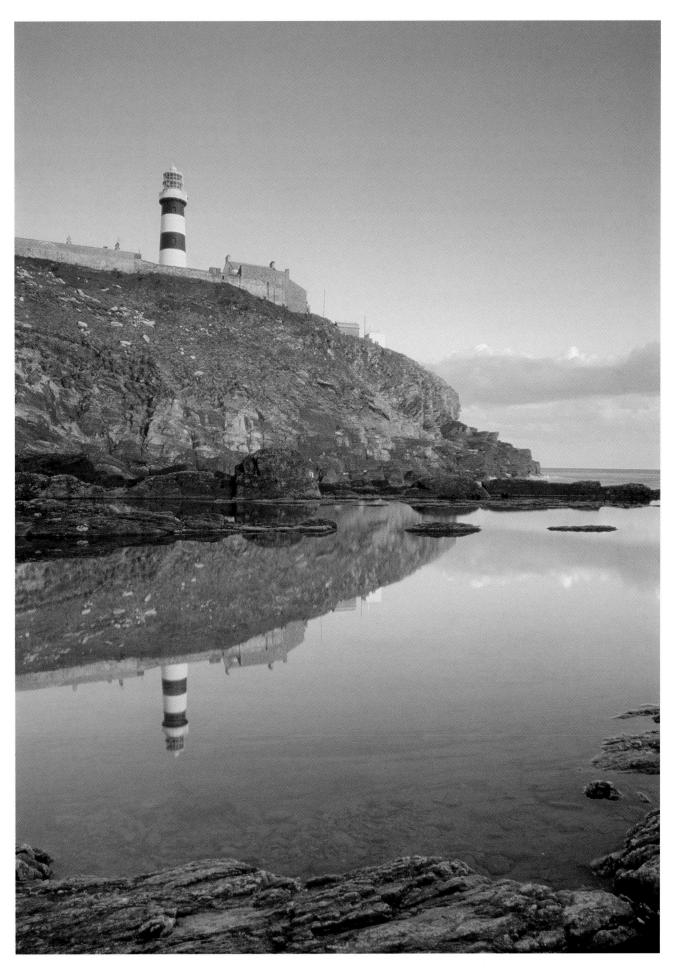

Above: Old Head of Kinsale, County Cork, Ireland.

without food or water until rescue came. The light is still in use, but only a few years after it was completed, the resident keepers were found to be actively involved in the smuggling of brandy and other contraband goods (which included packs of playing cards). They were only found out when the light was observed to be unlit. When an official was sent to investigate, he found the keepers drunk after having consumed some of the casks of brandy. This happened in 1821 and is a rare episode in the history of lighthouse keepers, who generally are renowned for their loyalty and steadfast devotion to duty in all circumstances.

The coasts of continental Europe are also guarded by a succession of lighthouses. Many of these are of great architectural or historic interest, and there are numerous stories and anecdotes associated with them. A string of lighthouses exists along the Dutch coast and the offshore islands of Telex, Vlieland, and Terscelling. Then follows the North German Coast with its numerous low lying islands and sandbanks, which was the setting for Erskine Childers famous novel, *The Riddle of the Sands*. Almost all of these islands carry a lighthouse of one sort or another.

Further north lies Denmark, Norway, and Sweden, all great maritime nations and surrounded by complex coastlines and literally thousands of islands. Sweden in particular has always been in the forefront of lighthouse technology and developed many of the lights and lamp systems currently in use. They also pioneered the telescopic concrete caisson method of construction. The first example of this was at Grundkallen where a lightship at the north end of the channel between the Swedish mainland just north of Stockholm and the Finnish island of Åland was replaced in 1961. While the caissons where built ashore, the seabed was leveled by blasting and the surface covered with tarmac. The completed caissons were then towed out and sunk in position, the outer being filled with ballast to act as the foundation, while the inner was raised and locked in position. As already related, this pioneering system, which drastically cut the time and effort needed to build a lighthouse, was employed with spectacular effect at the Kish Bank light in Dublin Bay. At home the

Swedes immediately adopted the method to construct a number of new lighthouses, including one at Falsterboreef built in 1971 and towed to its present location in 1972.

The completed structure of the tower at Towed is one hundred feet (30.5 m) above sea-level, and stands in a depth of fifty-nine feet (18 m). The total height of 159 feet (48.5 m) makes it Sweden's highest lighthouse structure. It is equipped with 192 sealed-beam 200-watt lamps (96 ordinary and 96 spare) giving a light range of twenty-two nautical miles (25 miles; 40.3 km).

Prior to the introduction of the telescopic caisson construction method, Sweden had already used simple caissons as foundations for more conventional lighthouses. The first of these was built in 1930 off the port of Trelleborg, at the extreme southern tip of the Swedish mainland. Although using a new construction technique, the iron caisson is granite faced and on this foundation was built a traditional conical lighthouse structure, the whole having a not unattractive appearance and contrasting sharply with the modern structures with their parallel-sided towers and capped by the now ubiquitous helicopter platform.

The other countries bordering the Baltic all maintain numerous lighthouses. One of the most intriguing and modern, is just off the island of Naissaar on the south side of the Gulf of Finland, and marks the approach to the Estonian port of Tallinn. The lighthouse here is an unprepossessing modern concrete structure which was originally completed in 1970. Externally it has little to distinguish it from numerous similar lights throughout the Baltic, but its secret lies deep within. Built by the Russians before Estonia became an independent state, its power source was originally a conventional electrical system supplied from diesel generators. However in 1973 it was converted to nuclear power—perhaps the ultimate source of light!

Above: The old lighthouse at Warnemunde, Meklenburg, Germany.

Above: Louisbourg, Nova Scotia, Canada.

The Canadian eastern seaboard is dominated by the approaches to the spectacular St. Lawrence River, which leads inland to the Great Lakes. The normal approach from the open waters of the North Atlantic is through the Cabot Strait between Cape Breton Island, Nova Scotia, and Newfoundland. As with most of eastern Canada, this area was originally colonized by the French. The fortified town of Louisburg on Cape Breton

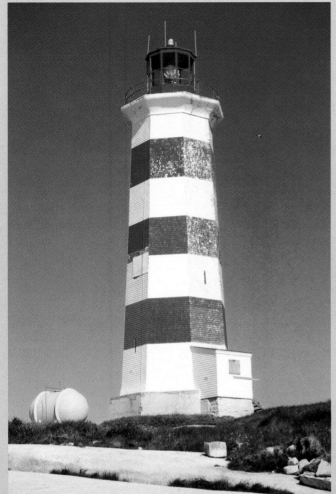 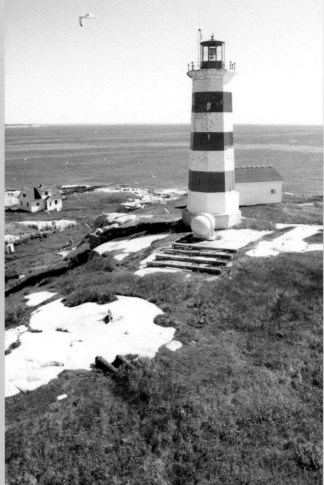

Island was of great strategic importance as it dominated the approaches to the river and, therefore, access the Canadian subcontinent.

The first lighthouse here was built on a rocky promontory just to the east of the town and was completed in 1734. Its design was based on that of Les Baleines (1682) off the French Coast at La Rochelle. It was seventy feet (21 m) high and its light consisted of thirty-one cotton wicks soaked in codfish oil. In 1736, this light was seriously damaged in a fire. A new lantern was built in 1738, and this was a substantial iron and stone structure with a more sophisticated multi-wick light that gave several years service until the lighthouse was again damaged, this time by military action during the siege of Loiusburg by British forces. Surprisingly it was to be almost a century before a new lighthouse was built and completed in 1842. This was a substantial stone tower with a ten foot (3 m) diameter lantern room at the top housing an oil-burning light system made up of nine separate lamps with reflectors.

Unfortunately this fine structure was destroyed in a fire in 1923 and was replaced in the following year by a concrete structure that remains in use today. However, unlike many contemporary concrete towers, the Louisburg example was remarkably decorative being of a tapering octagonal form with a considerable amount of interesting architectural detail in an attempt to echo the early history of the site.

Canada's next important lighthouse was at Sambro Island at the entrance to Halifax harbor. One still remains in use here today—laying claim to being the oldest continuously operating lighthouse on the North American continent—the first was erected in 1758 although, in fact, the present tower was actually built as a replacement for the original in 1896.

An alternative access to the St. Lawrence River was through the narrow Strait of Belle Isle between the Labrador coast and the northern shore of Newfoundland. In the 1850s the Canadian government erected a chain of lighthouses to guide steamships

Above: Two views of Sambro Island, Nova Scotia, Canada.

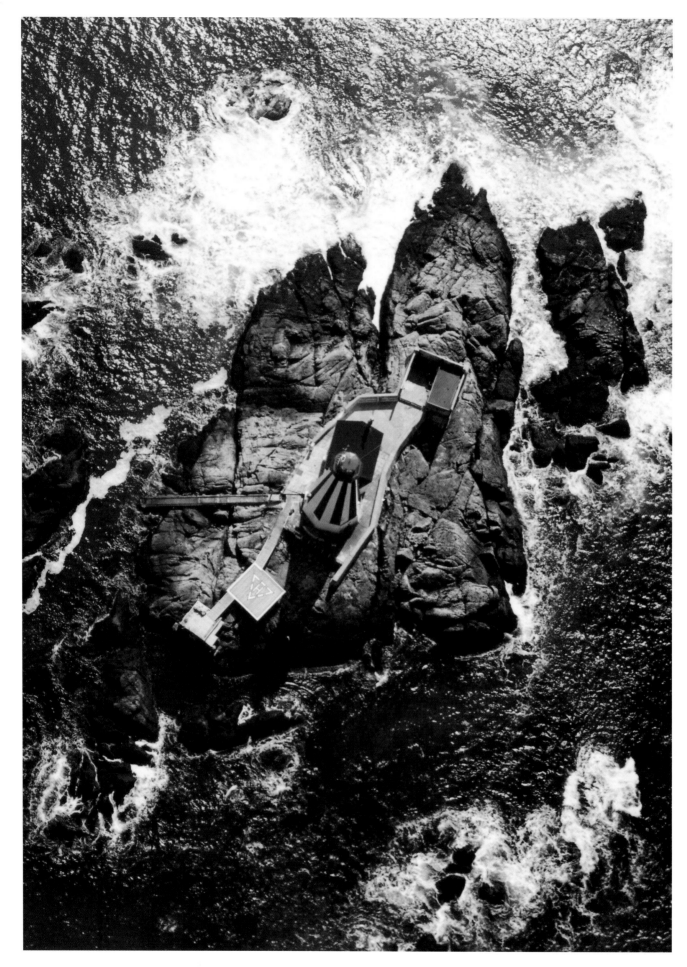

Above: An aerial view of Gannet Rock, New Brunswick, Canada.

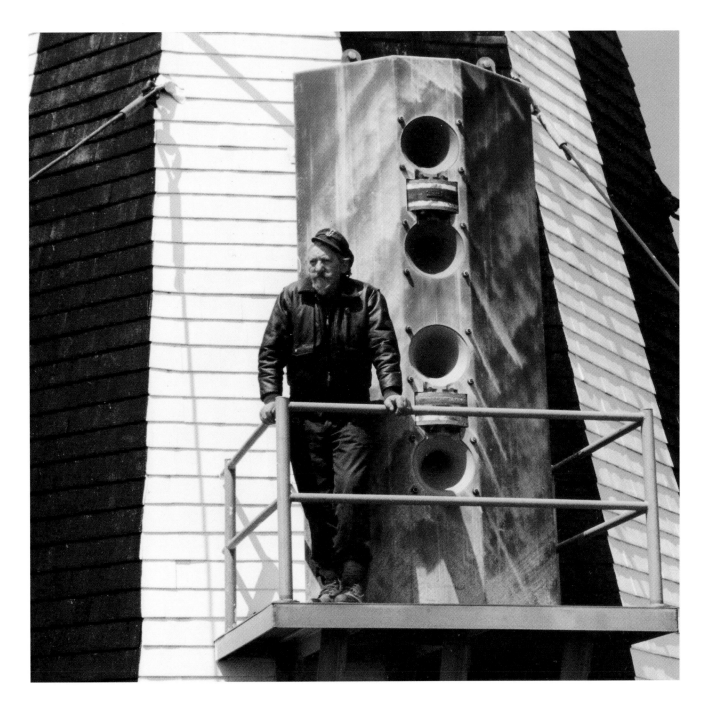

through the treacherous straits into the St. Lawrence River. This was a more direct route from Europe and, not being dependent on the wind, steamship owners were eager to utilize it. The tallest light was at Point Amour, but there were other lights at a Cap-des-Rosiers, West Point Anticosti, and Belle Isle itself. They were all built to a similar design although of differing heights to suit their individual locations. The builder was a Charles François-Xavier Baby of Québec, whose contract covered all aspects of masonry, carpentry, and joiner's work at the site. The new towers incorporated the latest techniques in lighthouse construction and technology with their Argand concentric whale-oil-burning wick lamp and the dioptric lenses and prisms developed in France by Fresnel. They were known as the "Imperial" lighthouses, mainly because they were funded by the British Government as essential aids to the seaborne trade of the British Empire, but their imposing stone outlines also warranted the name. Point Amour itself took four years to build and was

Above: The lightkeeper of Gannet Rock. Behind him is the lighthouse's foghorn.

completed in 1858. Standing 109 feet (33 m) high, it is currently the second tallest lighthouse in Canada. Despite the farsighted provision of the lights, the area still continued to claim many ships due to the combination of adverse weather conditions and treacherous shoals and reefs. Perhaps the most famous loss was that of the British cruiser HMS *Raleigh* which ran ashore in thick fog in 1922 when engaged on a cruise as flagship of the Royal Navy's North American Squadron. Remains of the ship can still be seen today.

The waters around Newfoundland and the approach to Québec along the St. Lawrence River was marked by many lighthouses, too numerous to mention here. Farther upstream lay the open expanses of the Great Lakes—vast inland seas that formed essential water highways for trade in central Canada and the northern United States. Navigational aids, including lighthouses, were needed in the Great Lakes, too. On Canadian

shores the oldest of these structures still in existence, although no longer operational, is at Gibraltar Point on Toronto Island. Built in 1808, it was actually decommissioned in 1907 after ninety-nine years of service. An older tower built in 1804 on Mississauga Point at the mouth of the Niagara River was demolished to make room for fortifications during the War of 1812. Other early lighthouses on Lake Ontario included False Ducks Island in 1828, Point Petre in 1831, Nine Mile Point in 1833, and Presqu'ile in 1840. The latter two are still standing, although Presqu'ile had its lantern removed in 1965. In that same year, False Duck was demolished, although its lantern eventually became the centerpiece of the Mariner's Memorial Lighthouse Park and Museum near Milford, Ontario.

Just as the seaward approaches to the St. Lawrence were graced with a chain of Imperial lighthouses, so also were the Great Lakes. In particular six Imperial

Above: Two views of Machias Seal Island, New Brunswick, Canada.

Above: Gannet Rock, New Brunswick, Canada.

Next page: Split Rock on the shores of Lake Superior near Two Harbours, Minnesota, US.

Towers were built at Point Clark on Lake Huron, and on islands named Chantry, Nottawasaga, Christian, Griffith, and Cove. Construction of these limestone towers was entrusted to John Brown (1808–76) and they were built to a basic eighty foot (24.3 m) design with the exception of Christian Island, where a fifty-five foot (16.7 m) tower comparable to Brown's 1858 lighthouse at Burlington was erected. The most southerly of the Canadian Great Lakes lighthouses was at Point Pelee, a prominent spit jutting well out into Lake Erie near Detroit. Interestingly this sixty foot (18.2 m) high wooden tower was built in 1859 on a caisson sunk just offshore, one of the earliest examples of this type of construction. It was replaced in 1902 by a steel-plated structure that has since been removed and erected in nearby Lakeview Park, Windsor.

The efforts of the various French, British, and Canadian engineers were matched by those of their American contemporaries. Almost at the western extremity of the lakes is an octagonal yellow brick lighthouse built at Split Rock near Two Harbours, Minnesota on the shores of Lake Superior. Although the tower is only fifty-four feet (16.4 m) high, it stands atop a 120 foot (36.4 m) cliff and consequently is one of the highest lights in the lakes. Despite its apparent isolated position, it was built in 1909–10 as an aid to the ever-increasing tonnage of iron ore extracted from the nearby Mesabe Mountains and shipped eastwards to centers such as Chicago and Detroit. Fierce storms in 1905 that cost 116 lives prompted its construction. Further east, on the southern shores of Lake Erie is the oldest operating light on the lakes. Built in 1821, Marblehead Light on Bay Point, Ohio, is a limestone tower standing some sixty-five feet (19.7 m) high. During the American Civil War, the nearby Johnson Island served as prison camp for some ten thousand Confederate soldiers. Some of these were involved in a dramatic escape bid in 1864 when sympathizers hijacked a passenger steamer and attempted to embark some of the prisoners. They were intercepted by a Union ship, *Michigan*, but some managed to escape into Canada.

Another light with Civil War connections is at Grosse Point, near Chicago, on Lake Michigan. This was built in 1873 and was fitted with a second order Fresnel lens, making it one of the most powerful lights on the shores of the Great Lakes. The lens itself had originally been installed in a Florida lighthouse, but the keeper had it removed and buried during the Civil War to prevent its use by the Confederates. It was later recovered and sent to the U.S. Lighthouse Establishment in Washington, where it was refurbished and stored until being dispatched for use in the new Grosse Point light.

Like many lighthouses, Grosse Point has a ghost story and this concerns a son of Aaron Sheridan, who was the keeper of another light at South Manitou. Sheridan, his wife, and one son were drowned as he rowed them out to the lighthouse one day, and the tragedy was witnessed from the shore by the other son. Much affected by what he had seen, he went on to become an assistant keeper at Grosse Point but later hanged himself there in a fit of depression. His ghost is said to haunt the lighthouse and manifests itself with strange noises, coldness, and other sensations that have reputedly been witnessed by many observers.

While the majority of Great Lakes' lights are ashore, there have also been some very creditable engineering projects comparable with those built in the open sea. One of these is located at Spectacle Reef in the Straits of Mackinac, a narrow stretch of water at the junction of Lake Michigan and Lake Huron. Although the reef was only some ten feet (3 m) below the water, the position was very isolated and the climate extreme. In winter the lakes froze solid with ice up to thirty feet (9.1 m) thick at times. The loss of two large steamers in 1867 on this reef led to the construction of an impressive ninety-three foot (28.3 m) stone tower. Work commenced in 1870 and took four years to complete at a cost of $406,000, well in excess of the original $100,000 estimate. Part of the problem was the severe storms that beset the area in winter; consequently, this lighthouse is often thought of as the Eddystone of the Great Lakes.

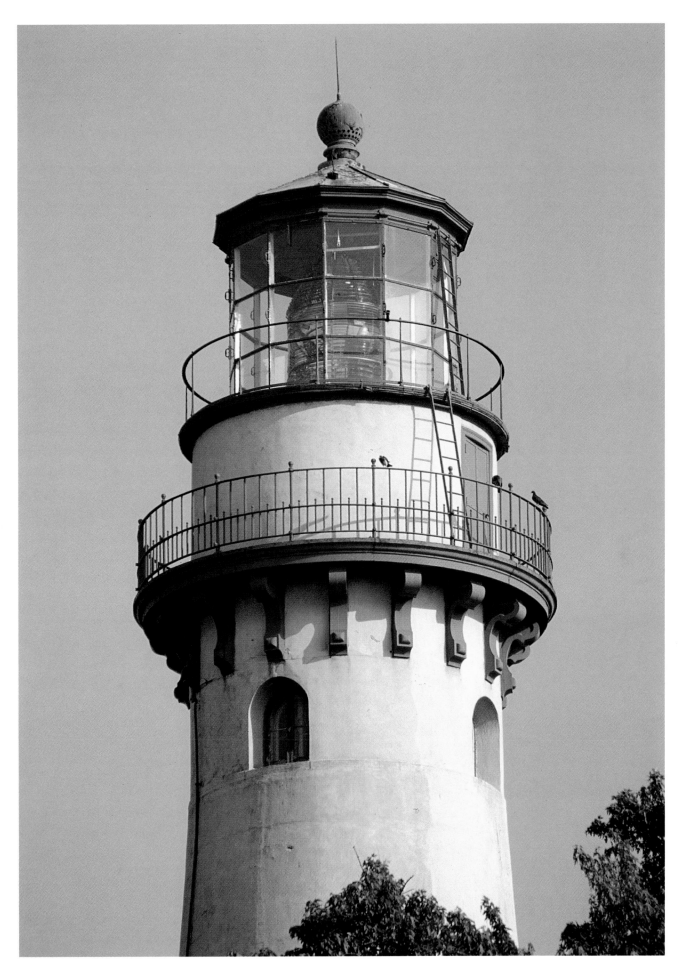

Above: Grosse Point, Michigan, US.

The development of America into a major nation began as European colonists settled on the eastern seaboard. The port of Boston rapidly became a major commercial center, used extensively by coastal and oceanic trade. It is not surprising to learn that America's first lighthouse was built here, on Little Brewster Island at the harbor

Above: Portland Breakwater, Maine, US.

Above: The lighthouse at Boston, Massachusetts, US.

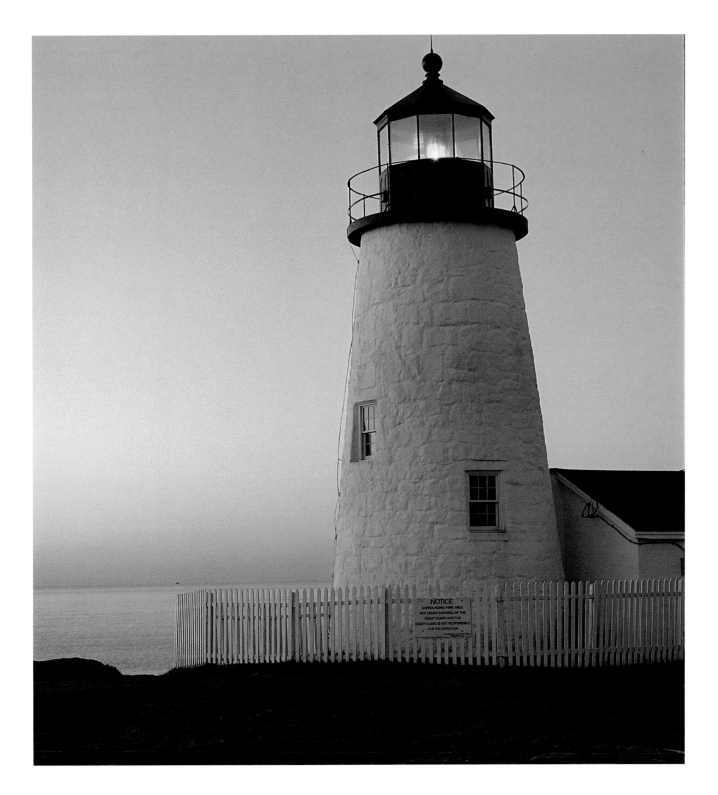

entrance, and was lit as early as September 1716. It was a stone tower with a light originally provided by candles but later replaced by an oil-burning lamp. In its time it has had more than sixty official keepers and today, by an act of Congress, is preserved in permanent working order as a monument to the Lighthouse Service. The first keeper was George Worthylake, and he appears to have been singularly unlucky. He was paid the sum of £50 a year to tend the lighthouse, but in an attempt to boost this income he started raising sheep kept on the nearby small uninhabited islands. However, during one fierce gale fifty-nine of his sheep were drowned, as he was too busy keeping the light burning to attend to his unfortunate animals. After this incident, he rowed ashore to the mainland to negotiate an increase in his pay to compensate for this loss and succeeded in

Left: Presqu'ile, Maine, US.

Above: Pemaquid Point, Maine, US.

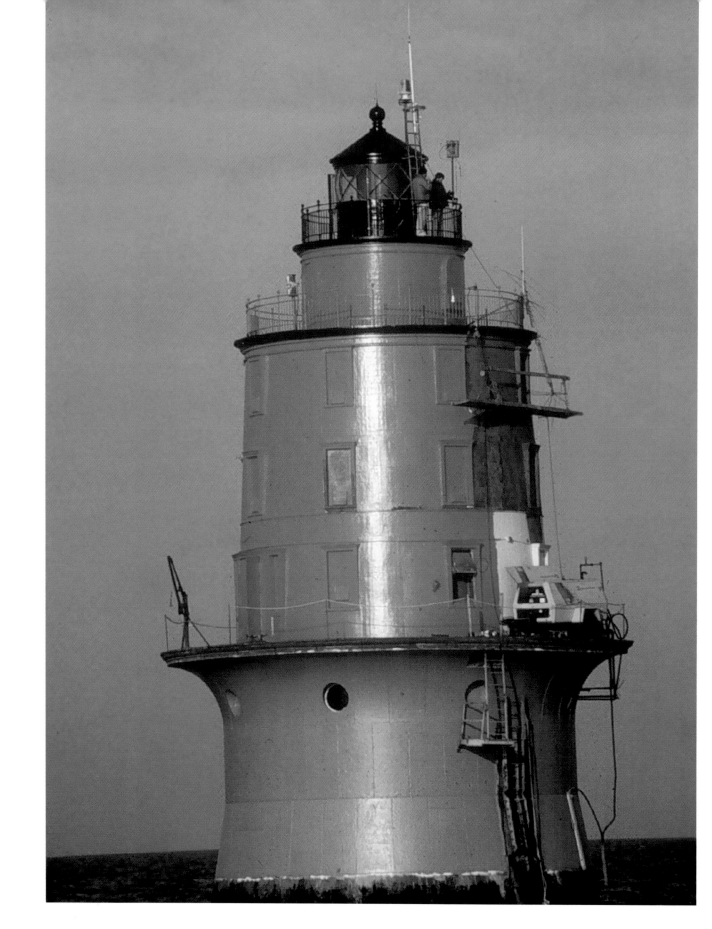

raising the figure to £70 a year, but some time later when returning to the lighthouse with his wife, daughter, and a slave, his boat capsized and all aboard were drowned. A similar fate befell the next keeper, Robert Saunders, who was drowned within days after starting his new job.

It might be thought that, with such a record, it would be difficult to recruit a new keeper, but one John Hayes took on the task. At his instigation a gun was placed on the island so that it could be discharged as a fog warning. Despite the additional duties involved in loading and firing this piece, Hayes still only received

Above: NOAA staff setting up a microwave navigation instrument on a lighthouse in Delaware Bay, Delaware, US.

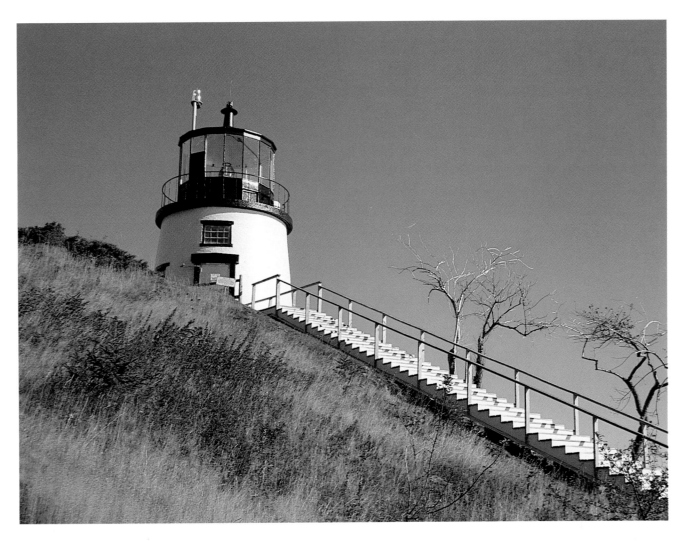

the basic £50 a year. In 1720, he was found responsible for a fire that caused severe damage to the structure, although whether it was deliberate or accidental is not recorded. Another keeper, Tolbia Cook, was convicted of fraud in the 1840s when he set up a cigar factory on the island using cheap female labor working under despicable conditions. He sold the resulting products as genuine, high-quality "Spanish Cigars" until their true source was discovered!

Another of America's early lighthouses and the oldest still in genuine operational use is the one at Sandy Hook on the south side of the entrance to the Hudson River and New York Harbor. This nine-story tower was completed in 1764, and contemporary local newspapers described it as America's finest light—not difficult when there were only three others in existence at that time! Interestingly, the keeper's original contract of service permitted him to keep two cows but insisted that the tower should not be used as a public house for

selling strong liquors. In the Revolutionary War, the Sandy Hook light was strategically important and was most useful to the ships of the British Royal Navy. Consequently, the New York Congress tried to dismantle the lantern to prevent it being used by the enemy ships. On observing this work, the British sent in a landing party and took over the running of the light. In June 1776, the tower was damaged when American militiamen bombarded it with cannon fire. They did not extinguish the light, however, which remained in British hands until the end of the war. In the mid-nineteenth century U.S. Lighthouse Board carried out a formal inspection of the lighthouse and its report can still be seen today. The report comments on the good condition of the structure, a tribute its builder Isaac Confro, but was quite scathing about the level of manning and the reliability of the light. At about the same time, the skeleton of a man was discovered in a secret compartment under the keeper's house, and just after

Above: Owl's Head, Maine, US.

World War II, Army engineers engaged on repairs to the tower found the bodies of four men and a women buried in the foundations.

Following the Revolutionary War, the government of the United States set up a formally constituted Lighthouse Board in 1789; at this time some twelve establishments came under their control. It is a measure of the explosive growth of the new nation's economy and the importance of its marine trade that in little over sixty years the number of lighthouses had risen to no less than 325. These were mostly maintained and manned by private concerns under contact to the Lighthouse Board who were, and remain, responsible for their inspection and the enforcement of standards. Not all of these were built on the shore, and one of the oldest and most interesting of the offshore lights was on the island of Matinicus,off the coast of Maine.

The island was a vast inhospitable reef on which a wooden lighthouse was built in 1827; it was replaced by a more solid granite structure in 1846. In 1851 the keeper, Samuel Burgess, lived there with his invalid wife and four children. While he was away on business, a terrifying storm blew up and completely washed away the old wooden buildings. It was several weeks before a landing could be made on the island with fresh supplies and he could return. During this period is oldest daughter, Abbie, who was only a young teenager, steadfastly tended the light and looked after the rest of family. Their main source of food was eggs laid by hens that Abbie had managed to save before the storm washed everything away. When Burgess left the Matinicus rock in 1861, Abbie remained behind and married Isaac Grant, the son of the new keeper. He in turn became keeper in 1875, so Abbie eventually lived on the rock for twenty-two years. Such family continuity was not uncommon in the days of manned lighthouses.

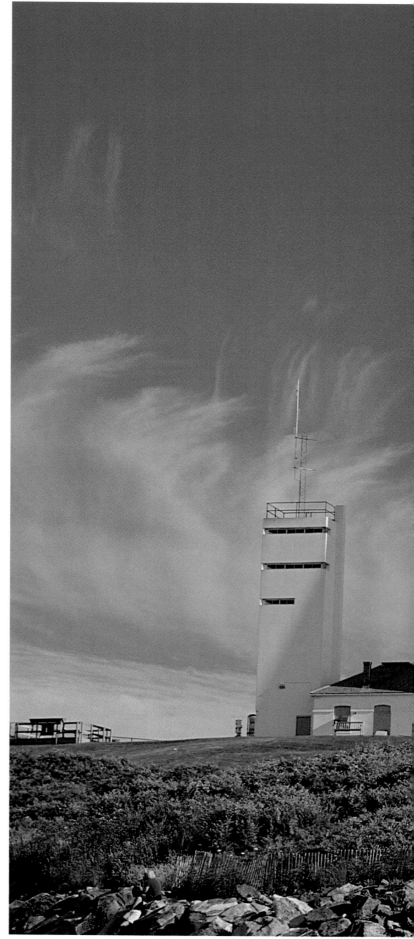

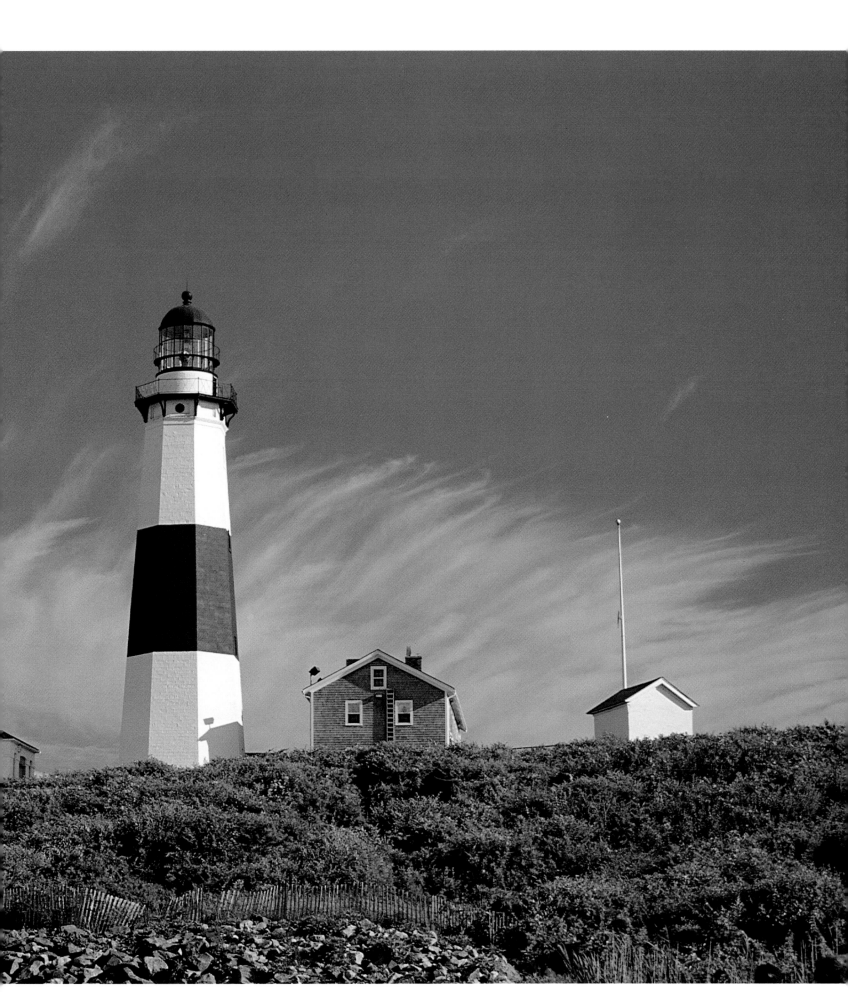

Above: Montauk, New York, US.

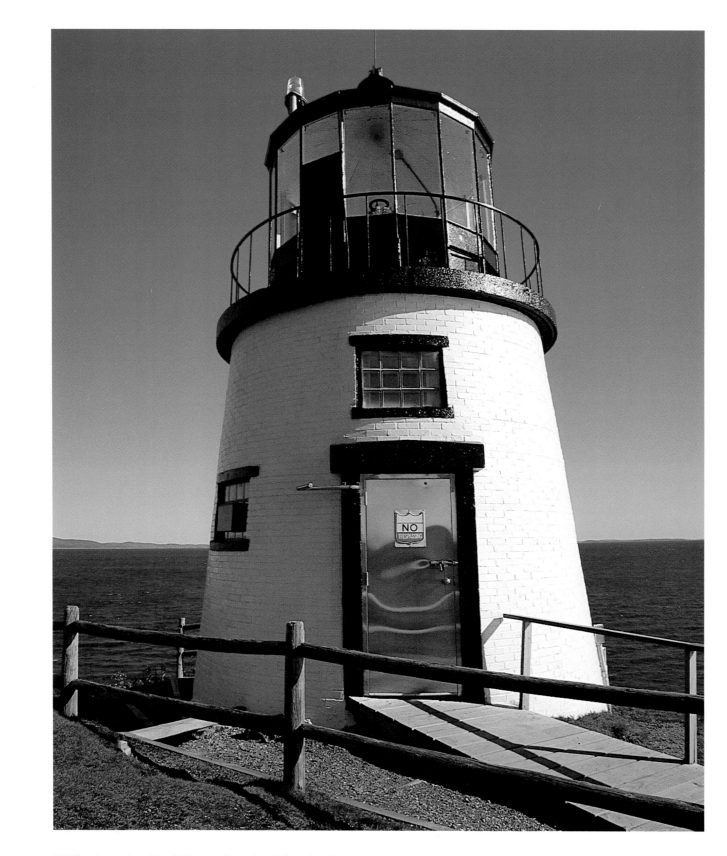

While the epic of building and maintaining the famous Eddystone lighthouse in Britain provided a rich seam of tradition for subsequent generations, the American equivalent might be considered the Minot's Ledge lighthouse set on a dangerous rocky ledge to the southeast of Boston. Between 1832 and 1841, no less than forty vessels foundered in this notoriously dangerous region, including six vessels from which there no survivors. These losses prompted various schemes to build a light although problems were

Above: Owl's Head, Maine, US.

formidable with an area only thirty feet (9.1 m) wide at best being uncovered at low tide.

Captain W.H. Swift began work on erecting a beacon in 1847 and his design comprised an octagonal building supported clear of the water by nine wrought iron piles, the idea being that waves would wash through the open gaps between the piles allowing the structure to withstand heavy seas. The light was finally completed at the end of 1849, and it was tended by two keepers who lived in a claustrophobic iron house below the lantern. Unwittingly, these two gradually provided the means for their own deaths when they began to store supplies such as fuel and water barrels on a deck that they constructed among the supporting piles. They also rigged a strong line from the top of the tower to a granite block on the rocks below and used this as a stay up which to haul supplies and visitors. On April 14, 1851, a great storm blew up, the same which marooned Abbie Burgess on Matinicus Rock, and within a couple of days it had assumed hurricane proportions. In the evening the light was still observed from the shore to be burning but was later extinguished, and when morning came there was no sign of the light or its keepers. All that remained were the stubs of the iron piles. Investigations supported the theory that the action of the waves against the storage deck and the stay line had exerted enough force to topple the light and drag it down into the raging sea. The bodies of the two keepers were never found.

Although short-lived, the Minot's light had already proved its worth, as the number of ships lost decreased drastically. There was no question that a replacement would be built. This was eventually to be a more traditional granite tower designed by General G. J. Totten of the Lighthouse Board and built under the supervision of Captain B. S. Alexander, an Army engineer. Due to lack of space, the tower was a pure conic section and did not feature the splayed base commonly seen in other similar structures. Work began in July 1855 but, due to the difficulties of landing on the rock in any but the most favorable conditions of wind and tide, it was not completed for another five years, with the light eventually being lit in November 1860. It has been in continuous service ever since, although converted to automatic operation in 1947.

The rock was a lonely place at the best of times, and perhaps this accounts for the insistent series of reports concerning ghostly sounds, such as doors closing and tapping on the walls of the tower. These were generally ascribed to the restless souls of Joseph Antoine and Joseph Wilson, the assistant keepers lost when the first lighthouse was destroyed. Even more intriguing were many stories from passing sailors of seeing a man, soaked from head to foot, clinging onto a rope outside the tower and speaking in Portuguese. John Antoine was of Portuguese descent!

One of the most prosperous of the new colonies was Virginia. Exporters of Virginian tobacco, cotton, and other goods gained access to the open sea from the ports along the Delaware and Potomac Rivers though the open waters of Chesapeake Bay. The southern entrance to the bay was flanked by Cape Henry, and this strategically important spot was a natural location for a lighthouse. However, one was not erected until 1792, and it had the distinction of being the first to be constructed under the auspices of the new United States Congress following the end of the Revolutionary War. Cape Henry is actually a sandy spit and the original lighthouse, an elegant sandstone structure, eventually became unsafe due to the movement of its foundations. Accordingly a new cast-iron lighthouse was built in 1881, and the two now stand side by side although only the later light is in use.

South of Cape Henry, the coastline of Virginia and North Carolina is made up of a series of great sandy spits known as the Outer Banks, which enclose large stretches of shallow open water such as Pamlico Sound. These are formed by the effect of the warm waters of the Gulf Current sweeping up from the south and cold Labrador Stream from the north. This quirk of geography leads to difficult currents and unpredictable weather. The southeastern promontory at a point where the line of shoals changes direction though almost 90° is known as Cape Hatteras. Nearby are the Diamond Shoals and the whole area is known, not without reason, as the graveyard of the Atlantic. Ships

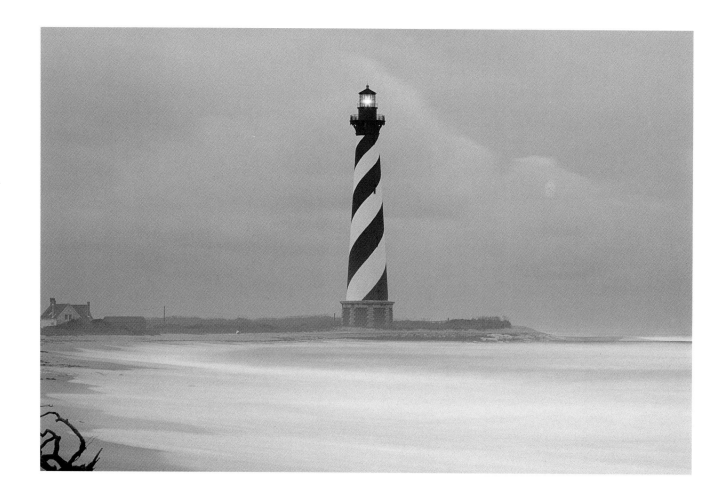

wrecked here include many Spanish galleons as well as the world's first turret-armed ironclad warship, the *Monitor*, and numerous merchant vessels in times of peace and war. Estimates of the numbers of ships sunk here vary between 600 and 2,300 but, whichever is the true figure, the dangers of this area and its numerous shifting shoals were well known. A ninety foot (27.3 m) light tower was first erected in 1802, but it was soon realized that it was not tall enough to be effective. The extent of the shoals demanded that any light should be visible well out to sea, so a new 208 foot (63 m) tower was built in 1873. It is still the tallest lighthouse structure in the United States.

There are several lighthouses along the length of the Banks, and in order to prevent misidentification, they are each painted in a distinctive pattern in addition to displaying their own coded lights. Cape Hatteras is painted in a distinctive black-and-white spiral striped pattern, Bodie Island has horizontal black-and-white stripes, Cape Lookout at the southern end has a black-and-white diamond pattern and Curritack Beach at the north end retains a natural red brick finish. For a few years before and after World War II, Cape Hatteras light was not in use, its function being carried out by a much newer light mounted on a steel lattice tower at nearby Buxton. In 1950, an automatic electric beacon was mounted on the old Cape Hatteras tower—less powerful than the great first order lens originally installed but still visible twenty miles (32.2 km) out to sea.

Despite its great height, the Cape Hatteras light still did not provide enough warning of the Diamond Shoals some ten miles (16.1 km) to seaward and although various attempts were made to provide some sort of lightship or floating beacon, none of these survived for any significant period. In 1889, the construction of a lighthouse was authorized and its method of construction was based upon that which successfully been employed in the erection of a lighthouse on the Fourteen Foot Shoal in Delaware Bay. This utilized a massive steel caisson that was towed out to the site and then sunk, to be filled with concrete and provide a solid base upon which construction could proceed. While

Above: Cape Hatteras, North Carolina, US.

this had worked as planned in Delaware Bay, the strong current and bad weather caused the caisson to break up, and it was not until 1966 that a permanent lighthouse was established on the shoals.

Farther south along the eastern seaboard of the United Sates lie towns such as Charleston and Savannah, which were important centers of trade and were among the earliest to be provided with lighthouses and other means of assisting mariners. One such lighthouse was on Tybee Island at the entrance to the Savannah River. It was erected on the orders of General James Oglethorpe, one of the early British settlers who founded the town. Built around 1736, the seventy foot (21.2 m) wooden tower was at that time the tallest structure of its type in North America, but it and a second tower built nearby both collapsed into the sea within a very short period. A third tower was built in 1773, but was damaged and burned by Confederate troops in 1862. Using sixty-six feet (20 m) of the original structure as a base, it was rebuilt in 1867, and its total height increased to 154 feet (46.7 m)—144 feet (43.7 m)

according to some sources. Although damaged by an earthquake in 1886, it remains in service today and a full restoration is being completed in 1999. Back in the nineteenth century, it is said that the sands around the lighthouse were a popular spot for duels to be fought with the keeper as the sole spectator and witness.

Just off Tybee is the Cockspur Island Lighthouse that can be reached on foot at periods of low tide. This was built in 1848 and is associated with a girl named Florence Martus, the sister of one of the keepers. In 1887 she fell in love with a sailor who, as sailors were wont to do, swore to return and marry her. He never did, but Florence remained ever hopeful and for the next fifty years, she expectantly waved a white handkerchief at every passing ship. She became familiar to the crews of the numerous ships that passed and they began to buy little gifts for her, picked up on their travels to far-flung parts of the globe. She no doubt took great pleasure in these little tokens but was probably a little taken aback to receive, on one occasion, a llama brought all the way from Peru!

Above: The silhouette of the lighthouse at Brunswick, Georgia, US, against the night sky.

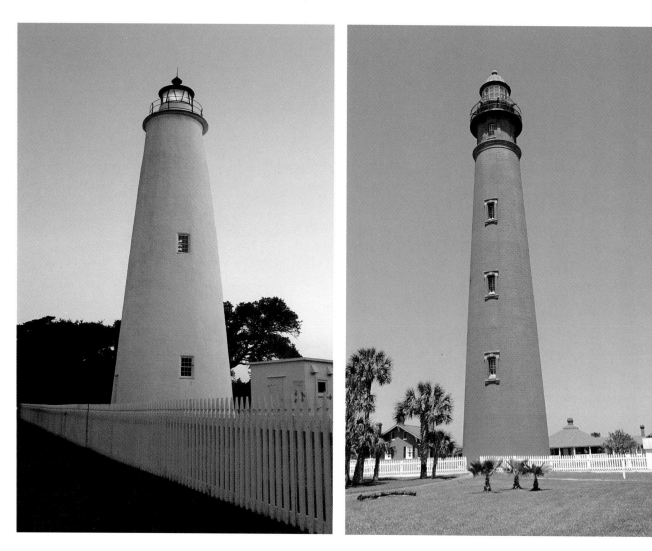

South of Georgia, the coast follows the great sweep of the Florida peninsula, which eventually tapers off into the famous Keys, a series of small islands stretching out into the tropical waters of the Caribbean. There are numerous lights along the coast, and perhaps one of the most interesting is the Ponce de Leon Lighthouse at a location just south of Daytona Beach known as Mosquito Inlet. Ships had wrecked here as far back as 1565 when a French fleet ran aground but it was not until 1834 that an attempt was made to build a lighthouse. This first attempt collapsed in a storm before it was completed. Hostile Seminole Indians prevented its rebuilding, and the site was abandoned for almost fifty years. A completely new lighthouse was completed in 1887, even though its chief engineer, Major O. E. Babcock was drowned while visiting the construction site in 1884. Nevertheless, the resulting tower was the second highest on the East Coast and stood some 175 feet (53 m) tall. Its original first order Fresnel lens

weighed some 2,000 lb (900 kg). When a beacon at the nearby New Smyrna Coast Guard Station was introduced in 1970, the lighthouse was decommissioned and handed over to a preservation society who are today responsible for the whole complex including the tower, accommodation, and stores, and the adjacent boatyard. Modern high-rise developments subsequently obscured the New Smyrna beacon, so one was installed in the Ponce de Leon lighthouse in 1983, although the site and museum are still open to the public.

Another lighthouse that suffered from the attentions of Seminole attacks was at Cape Florida on Key Biscayne, which was first built in 1825 just a few miles off what is now Miami. In 1836, a war broke out with the native Seminole Indians, and the keeper William Cooley left after his wife and children were killed in a raid. A few months later, a new keeper, John Thompson, and his assistant were trapped by another Indian attack and were forced to flee to the top of the tower as the

Top left: Okracoke, North Carolina, US.

Top right: Ponce Inlet, Florida, US.

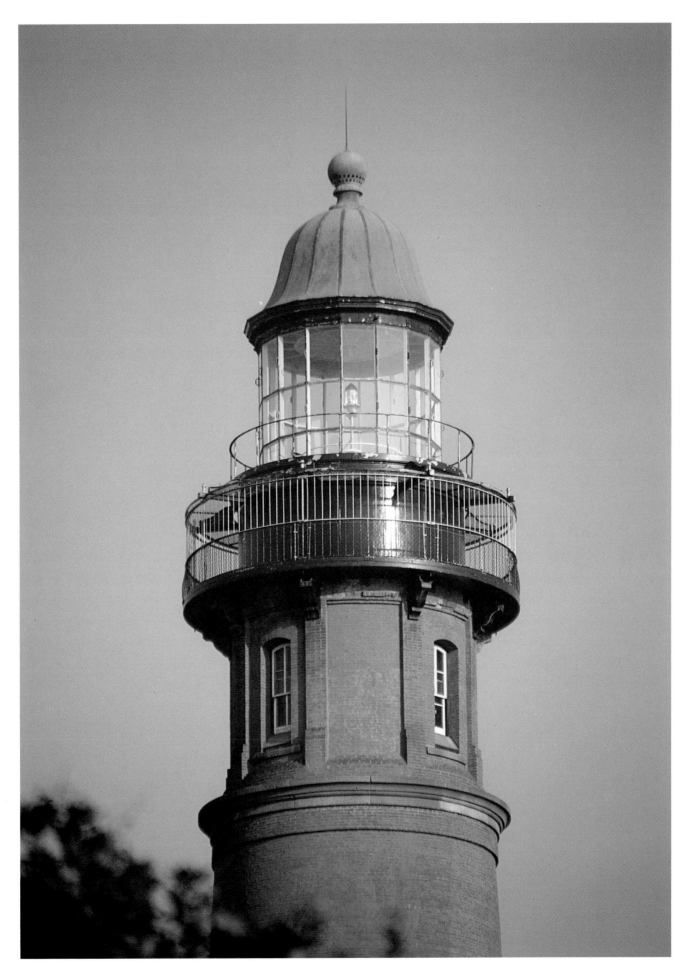

Above: Ponce de Leon, Florida, US.

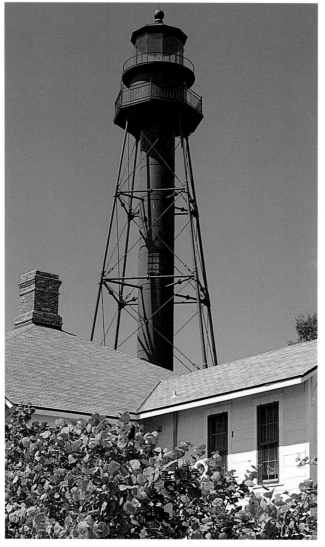

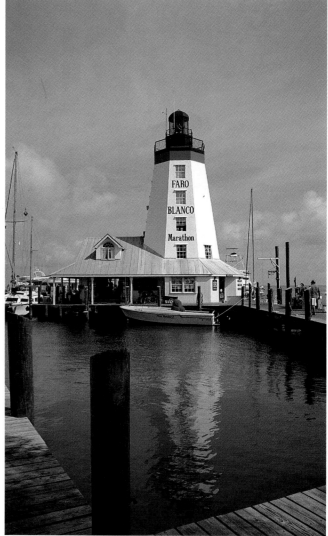

attackers set fire to the base. On the verge of being burned to death as the flames crept higher and higher, Thompson threw down a keg of gunpowder in a desperate attempt to destroy his persecutors even if it meant his own end. The outcome was rather bizarre, however. Few, if any, of the Indians were killed in the explosion, but they in turn assumed that the keepers had been killed and made off with their spoils after burning down the remaining storehouses and buildings. In fact the assistant keeper was dead from a combination of burns and bullet wounds, but Thompson survived, lying in agony from major burns and other injuries and plagued by mosquitoes which tormented him until help arrived from a passing naval ship some twelve hours later. He did eventually recover, although he never regained full fitness. After the Indian wars died down, the tower was rebuilt in 1846, but it suffered a further setback when it was damaged by a

Confederate raiding party in 1861, putting it out of commission for some time. It finally fell into disuse when it was replaced by a new lighthouse on Fowey Rocks in 1878. This was an altogether different structure, built on a reef a few miles offshore from Miami. The lighthouse was a two-story octagonal structure supported on iron piles driven into the rock. The lower platform, some eighty feet (24.3 m) square contained the keepers' accommodations, while the light was housed in the upper storey, some 110 feet (33.3 m) above sea level. The old Cape Florida lighthouse was later restored and the light relit in 1978. Today it is a major tourist attraction and is the oldest standing structure in South Florida.

Almost at the extremity of the Florida Keys is the famous Key West island where a lighthouse has stood since 1825 to mark the northern edge of the Florida Straits between the Keys and Cuba. The original eighty-

Top left: The lighthouse at Sanibel Island, Florida, US.

Top right: Faro Blanco at Marathon, Florida Keys, US.

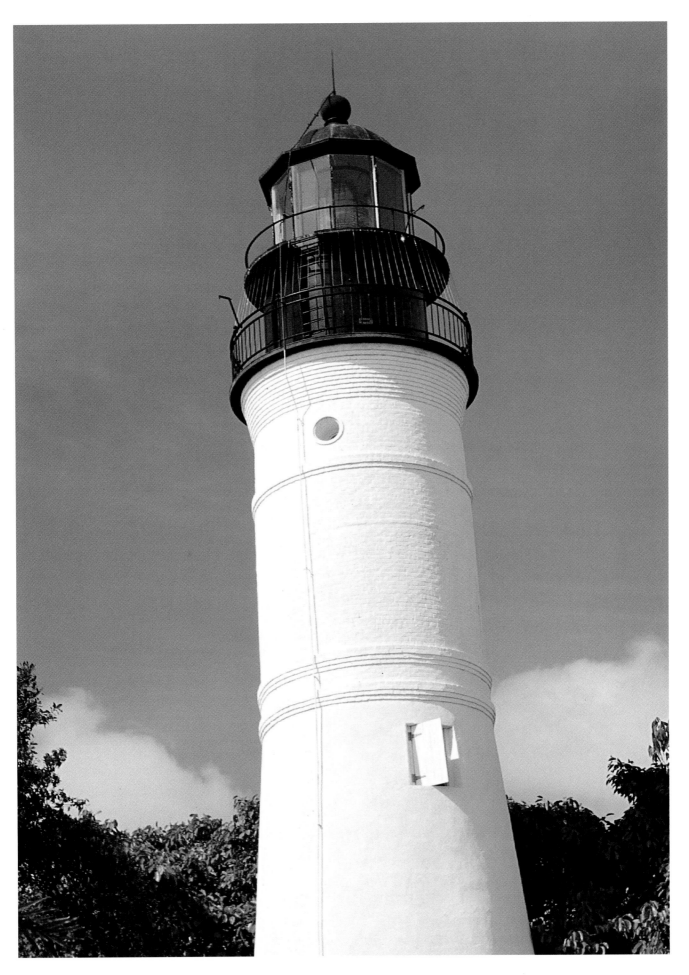

Above: Key West, Florida, US.

THE EAST COAST OF THE UNITED STATES

five foot (25.8 m) high tower stood until 1846 when it was destroyed in a sudden storm. The keeper was a widow, Barbara Mabrity, who had taken on the task after the death of her husband and lived there with her eight children. On the night of the storm, some twelve islanders also sought shelter in the lighthouse, but when it collapsed many of them were trapped and killed. Only Barbara, one of her children, and five of the islanders survived this terrible tragedy. A new tower was erected almost immediately and was further enlarged in 1890. It remained in use until 1970 when it was decommissioned, paradoxically, because it was too far from the sea to be effective!

Elsewhere along the length of the Keys are a number of reef lights built on the screw pile principle. Several of these were completed between 1850 and 1890 but another five or six were added in the 1920s and 1930s. These include Carysfort Reef (1852) reputed to be haunted by the ghost of Captain Johnson, one of the original keepers, and Sand Key Reef (1853), built to replace an earlier tower washed away in a hurricane in 1846. All of these are now automated and unmanned, although the American Shoal light off Sugarloaf Key was manned in 1980 to monitor an exodus of refugees from Cuba at that time.

Above: The shadow of Sand Key Lighthouse, Florida, US.

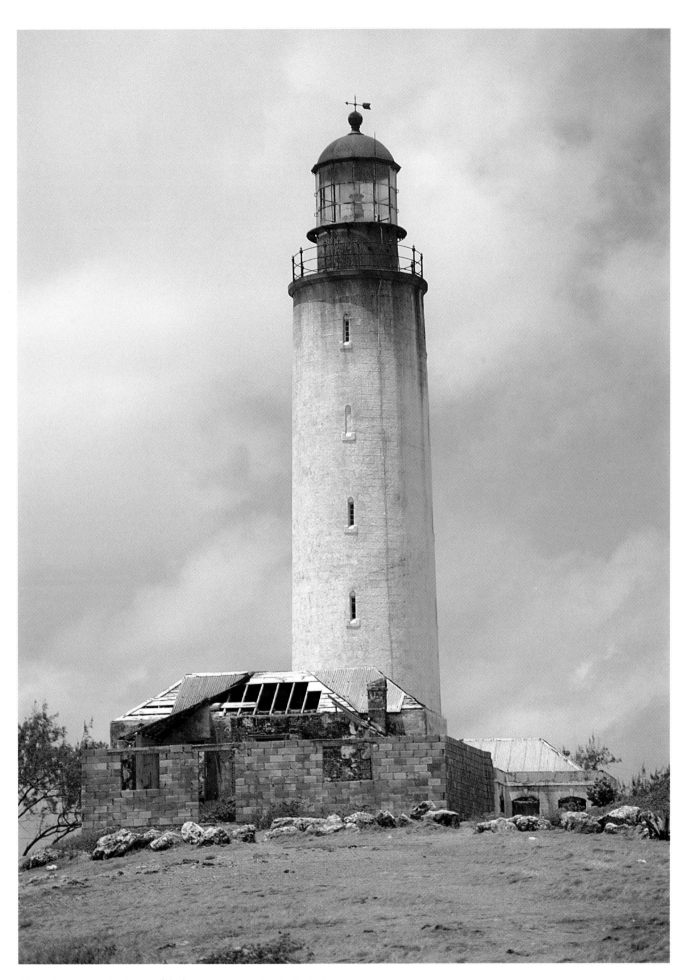

Above: The East Point Lighthouse, Ragged Point, St. Philip, Barbados.

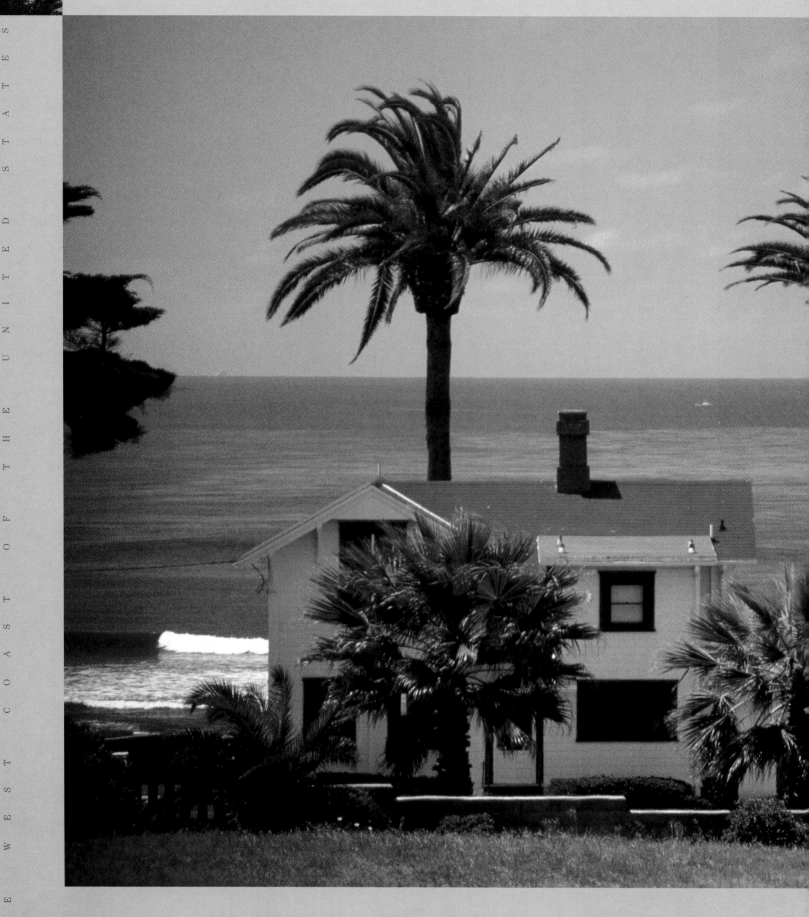

THE WEST COAST OF THE UNITED STATES

Above: New Point Loma, San Diego, California, US.

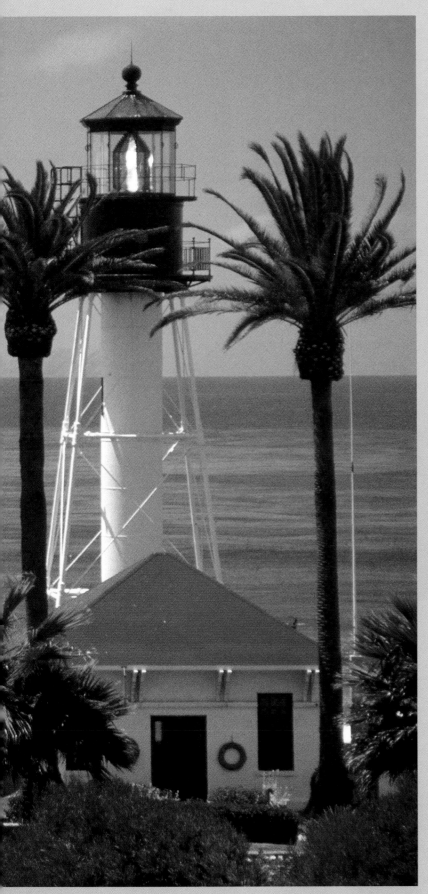

The West Coast of the United States is open to the rolling swells of the Pacific Ocean, built up by the prevailing westerly winds, while the coast-line itself often consists of craggy cliffs where foothills of the Rocky Mountains reach the sea. There are several major maritime centers situated here, of which the most important are probably San Francisco and Seattle, although San Diego and Los Angeles are also significant. In addition there are numerous smaller harbors which in the nineteenth and early twentieth centuries provided the only way in which many goods and merchandise could reach settlements west of the Rockies. The building of lighthouses and other aids to navigation lagged a little behind developments on the East Coast, reflecting the fact that the colonization of the West Coast occurred relatively later. The state of California, originally opened up by Spanish explorers, attracted a rush of new settlers during the great gold rushes of the early and mid-nineteenth century and from then on the various ports and harbors became ever busier.

One of the earliest Californian lighthouses was at Point Loma on the northern side of the entrance to San Diego Bay. This was completed in 1855, but, rather embarrassingly, after the main structure was complete, it was found that the first order Fresnel lens intended for installation was too big and could not be fitted. It was therefore diverted to another lighthouse at Humboldt Bay in the north of the state, while a smaller third order lens was mounted instead. Nevertheless, this could still be seen from up to forty miles (64.4 km) away in the right conditions, mainly because it was built on top of a small hill, placing that light source some 460 foot (139.5 m) above sea level. Unfortunately in conditions of low cloud, the light would be obscured and not visible from the sea. A new tower was therefore built lower down in 1891, and this remains in use today, known as New Point Loma to distinguish it from the old structure which now forms part of the Cabrillo National Monument, a popular visitor attraction.

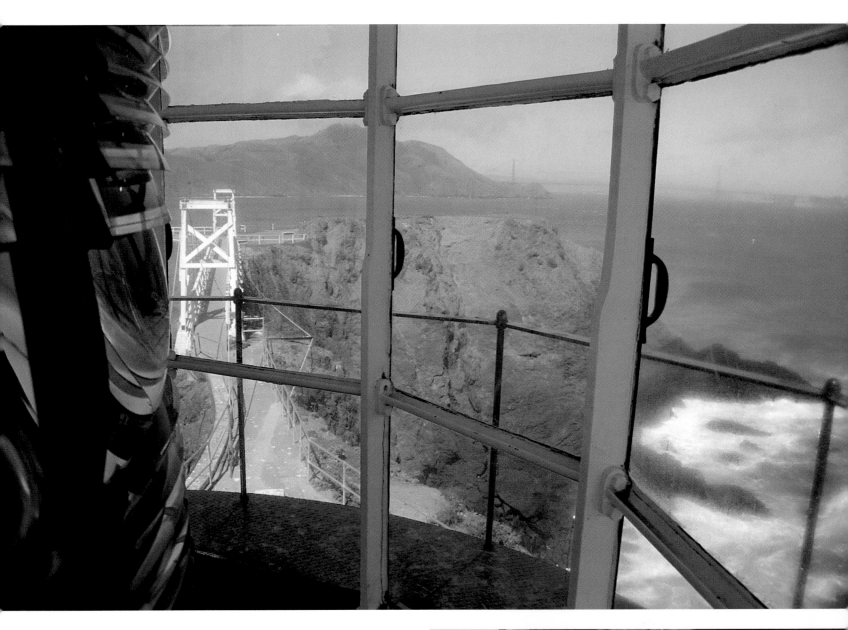

The Los Angeles area was well provided with lights. Its major port area was Long Beach, and there were lighthouses at Point Farmin and Point Vicente. Offshore lay the Channel Islands, almost all of which were eventually provided with lighthouses to mark the channels approaching the Los Angeles area. Some 350 miles (563.5 km) north along the coast lies the Golden Gate, entrance to one of the world's great natural harbors at San Francisco. On the north side of the Golden Gate is Point Bonita, which has been the site of two major lighthouses, the first of which was completed in 1855 and stood a total of 306 feet (92.8 m) above the sea, where it suffered from the low cloud and sea fog for which this part of the coast is notorious. In order to provide a warning to ships in such conditions a 24 lb cannon was

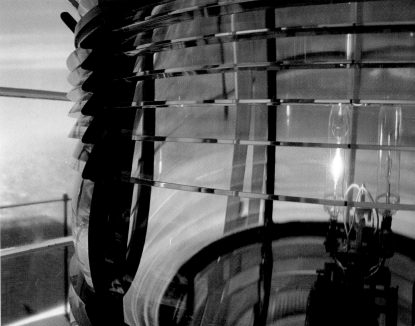

Above: and right: Point Bonita, California, US.

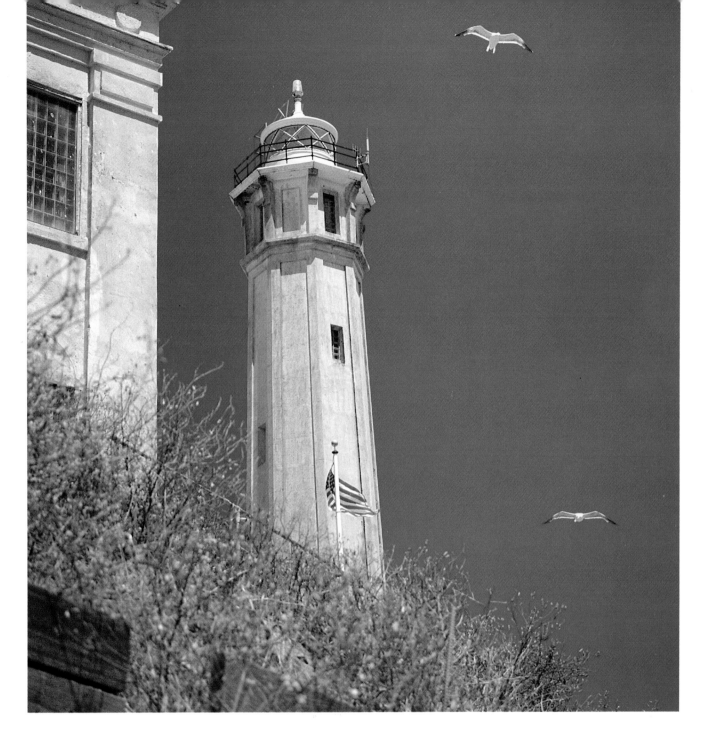

installed with instructions from the U.S. Lighthouse Board for it to be fired every half hour while fog prevailed. Unfortunately they ignored the fact that the keeper was alone in the light with no direct access to the mainland. On one occasion, in a magnificent display of devotion to duty, he fired the gun as directed over a period of three consecutive days, unable to snatch even the shortest period of sleep. When he wrote to complain of his situation, he was replaced, but at least the cannon went as well, its work instead done by an automatic mechanical bell. A new tower was built on the rocks at Point Bonita in 1877, and it stood only 124 foot (37.6 m) above the waves so that it was less often obscured. However, the keepers here still continued to suffer hardships, and their accommodation was destroyed in

the 1906 earthquake which destroyed much of San Francisco. It was rebuilt, but the situation on the edge of a rocky ledge was perilous, and this was dramatically illustrated in 1915 when one of the then keeper's children fell over the cliff. Fortunately his wife was in the practice of not allowing the children out to play unless attached to a tether and this had saved the young child's life—although she was left dangling for some time until her absence was noticed!

Just inside the entrance San Francisco harbor is the famous Alcatraz Island, best known for its infamous prison. The island was also the site of the first permanent lighthouse on the West Coast, this being completed in 1854. When the original military prison was enlarged in 1909, it partially obscured the light and

Above: Alcatraz Island, San Francisco, California, US.

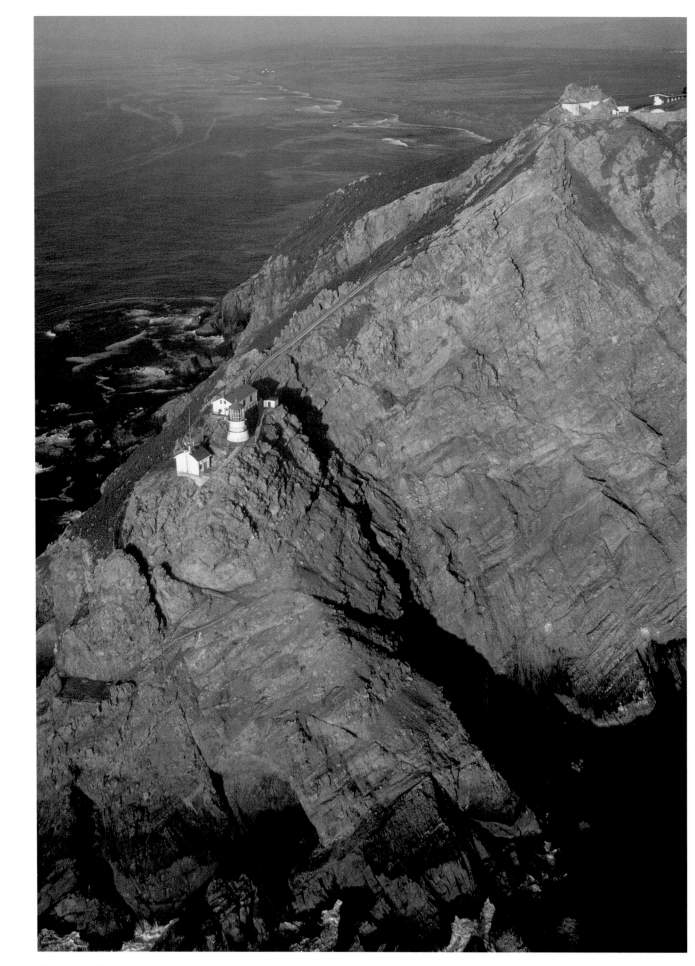

Above: Point Reyes, California, US

a new reinforced concrete tower was built to replace it. This contained accommodation for three keepers and their wives who shared the island with the prisoners and the guards. This situation led to some interesting arrangements for routine activities, such as shopping or sending the children to school. There were even special provisions for the disposal of ordinary household rubbish to prevent the possibility of anything that might form the basis of a weapon reaching the inmates. The prison eventually closed in 1963, but the light remains, although it is now automated.

A few miles northwards along the Pacific coast from the Golden Gate is the Point Reyes peninsula, which juts right out into the sea and forms a natural hazard to ships heading up and down the coast to and from San Francisco. As early as 1595, a Spanish ship, the *San Augustin*, was wrecked here, and over the next three hundred years, there were many more losses. It was an obvious site for a lighthouse and the U.S. government had plans to build one in 1853; however, the owners of the land refused to sell other than at the vastly inflated price of $25,000. It took another seventeen years before negotiations were concluded and the 120 acre (48.6 ha) site was bought for $6,000. During that time at least another fourteen ships were lost.

In order not to be continually obscured by cloud and fog, the lighthouse was built low down near the water's edge and was reached on foot by means of three hundred steps leading down the steep cliffs. In fact the Point Reyes promontory must be one of the most inhospitable places in America. It is officially the country's windiest headland and also its foggiest with some 2,700 hours of clinging damp fog recorded annually. The waters off the headland are swept by treacherous currents with dangerous tidal races. The lighthouse itself was actually of iron construction and, due to the awful conditions, it was not a popular station for the keepers from the U.S. Lighthouse Service. An added strain was the frequent sounding of the fog siren. On one occasion it was recorded that the siren had been operated continually for 176 hours (over a week!) by which time the keepers were described as being jaded and appearing as if they were drunk. In fact, the station had a record

of constant staff changes and many of the keepers did take to drink to escape the rigors of the life.

Still it was not all bad news. In 1929, the U.S. Coast Guard received a call that a fishing boat had foundered below the lighthouse and the three crew members were clinging to the rocks in imminent danger of being swept away. It took some time for them to get to the scene with their rescue gear, and when they arrived there was no sign of the boat or any survivors. Fearing the worst the rushed to the lighthouse to telephone their headquarters and organize a sea search, only to find all three enjoying coffee and biscuits in front of a roaring fire in the house of the keeper, Fred Kreth. He had singlehandedly climbed down the cliffs with rope and tackle and had rescued the grateful survivors! The tradition of lighthouse keeping families at Point Reyes came to an end in 1951, when responsibility for the light was transferred to the U.S. Coast Guard.

Almost at the northern extremity of the California is Crescent City, a small port whose main trade centered on the timber from the redwood forests of the hinterland. The city itself only sprang up in the wake of the 1849 gold rush. A lighthouse was erected in 1856 on Battery Point, and its first keeper was a man named Theophilus Magruder, who had an interesting history. He had come to Oregon and California from Washington D.C. with a friend, Jon Marshall, to prospect for gold. Their search was initially unsuccessful and the partnership broke up, but Marshall carried on and in 1849 discovered rich seams in the Sierra Nevada foothills. It was this strike which precipitated the great gold rush of that year and completely altered the fortunes of the state of California. Theophilus must have regretted that he did not persevere with Marshall, and even his period as a lighthouse keeper was relatively short. He resigned in 1859 when the Lighthouse Service reduced keepers salaries from $1,000 to $600 per year. The lighthouse itself was relatively modest, housing only a fourth-order lens, but it has survived the test of time and still stands today, even after being hit by a series of tidal waves in 1964 after an earthquake in Alaska. These waves, known as tsunamis, destroyed most of the commercial center of the town and killed eleven people.

Although the light at Battery Point had no particular merit from the architectural point of view, the same could not be said of the lighthouse itself, built on a series of rocks known collectively as St. George's Reef, some thirteen miles (21 km) offshore from Crescent City. These rocks were the tip of a submerged volcanic mountain and presented a considerable hazard to coastal trade, although the need for a lighthouse was not finally acknowledged after the loss of the steamer *Brother Jonathan* in 1865. Over 150 passengers and crew members perished, although nineteen survivors were rescued by the Crescent City lifeboat. Work on preparing the foundations for a lighthouse on Northwest Seal Rock began in April 1883, high explosives being used to level the site. It took another year to build up a seventy foot (21.2 m) diameter circular granite base. Lack of funds then slowed further work, and it was not until 1892 that the 134 foot (40.6 m) high tower was completed and the light commissioned. The total cost had been $704,633, well in excess of the budgeted $100,000, and the raising of this money was one of the reasons for the delay in completion. It was the most expensive U.S. lighthouse to date. Its isolated position, coupled with the difficulties of landing in the heavy swell that normally prevailed, led the Lighthouse Commission to decide that no families would be allowed, although a staff of five keepers was established. The wisdom of this decision was sadly illustrated in 1951 when three members of the Coast Guard were drowned while attempting a routine transfer of stores and personnel to the rock. In the following year, a fierce storm lashed the lighthouse, and on one occasion, a massive wave crashed against it and smashed the windows in the lantern—146 feet (44.3 m) above sea level! The light was finally decommissioned in 1975, but in 1996 a preservation society was given responsibility for the lighthouse building and is currently restoring it for public viewing, although the only way of visiting will be by helicopter landing on a specially constructed platform.

The St. George's Reef light was the work of Charles Ballantyne, who had earned a reputation as a lighthouse engineer par excellence by building a lighthouse on Tillamook Rock off the mouth of the Columbia River on the Oregon coast. The geography of this area is totally inhospitable, with cliffs and hills rising 1,500 feet (455 m) straight out of the sea and littered with many offshore rocks. In the winter it was shrouded in fog, while even in the summer smoke from forest fires often hung in a pall over the sea. Tillamook Rock was an isolated outcrop of basalt rock rising to a height of 120 feet (36.4 m) above sea level and its sheer sides made access and landing very difficult. In fact, as the first working party was landed in September 1879, one of the stonemasons slipped and fell into the water and was carried away by a freak wave before he could be rescued. This seemed to put a jinx on the enterprises, and it became difficult to recruit the necessary labor force. However, Ballantyne persevered, and together with a small party of men, he began hewing and blasting the top of the rock to prepare a base for the lighthouse some ninety feet (27.3 m) above the sea. In January 1880, they were hit by a violent storm that carried away the store building and threatened to do the same to the living quarters, where the frightened men huddled in fear for eleven days until the storm began to abate. It was another two weeks before a boat was able to reach them and land water, food, and supplies. The subsequent work seemed easy in comparison and all building work was completed by February 1881 with the light actually being commissioned the month before.

Unfortunately, the lighthouse was not completed soon enough, as a merchant ship, *Lupatia*, struck a nearby rock and was lost with all on board in a gale on New Year's Day 1881. The only survivor, picked up by the horrified lighthouse builders, was the ship's dog, whose plaintive barks had been clearly heard from the rock as the ship went down.

The lighthouse on Tillamook Rock consisted of a single-story building in which each keeper had his own small room, together with a kitchen and store rooms. The lantern was housed in a forty-eight foot (14.6 m) high square tower above this building, putting the light 132 feet (40 m) above the high water mark. The total cost had been only $123,492 and this figure must have provided the basis for Ballantyne's estimate for the cost

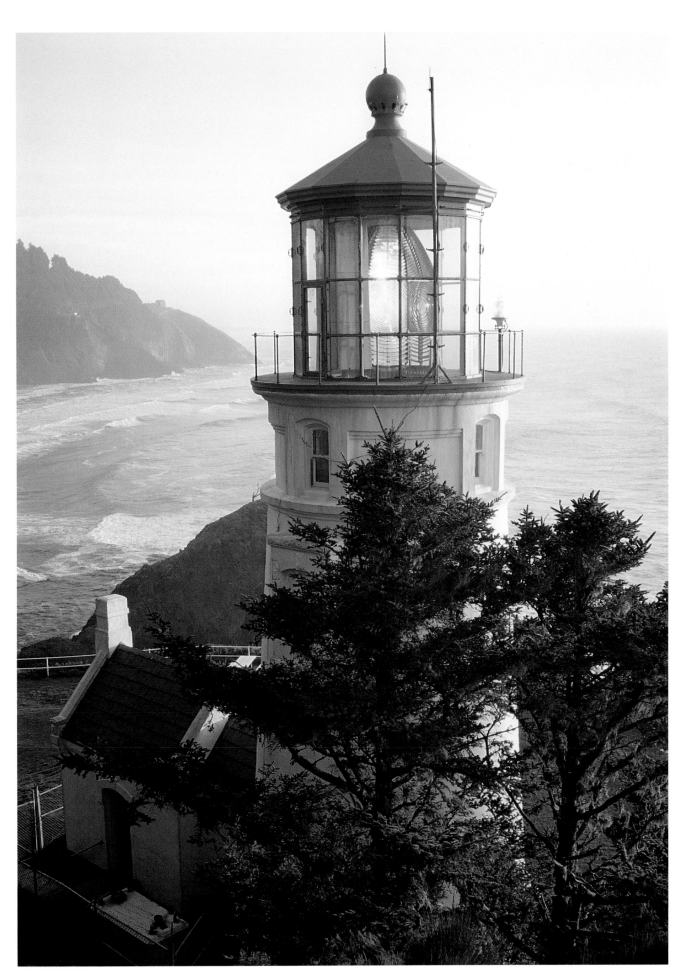

Above: Heceta Head, Oregon, US.

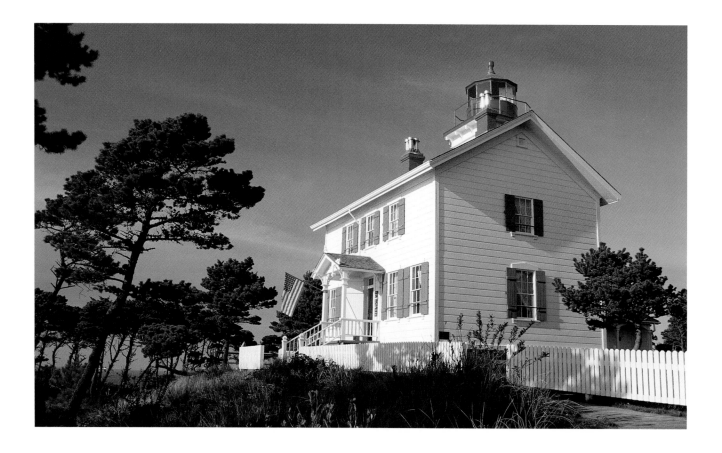

of building the later St. George's Reef lighthouse, although, as we have seen, it was to prove wildly inaccurate.

Even after its completion, Tillamook Rock continued to be battered by fierce storms. One of the worst was in 1886, when the roof on the south and west side of the building was crushed and other severe damage done. This was repaired and the light remained in service until 1957 although its subsequent history is by no means uneventful. It was eventually sold to a General Electric executive who planned to turn it into a summer retreat but later abandoned the idea. After one or two other similar ill-starred attempts, it passed into the ownership of an organization known as Eternity at Sea, who came up with the idea of using as what they termed a "Columbarium," a place where people could pay a fee to deposit the ashes of their loved ones in specially-commissioned urns. Provisions were made for the storage of up to a hundred thousand urns, each one carried in by helicopter (all included in the price). However the response to this idea has not been overwhelming and very few are actually deposited on the Rock.

The treacherous Oregon coast was served by several lighthouses, including one at Yaquina Bay that was operational for only three and a half years! In fact for many years much credence was given to a story that it was built on the wrong headland by mistake and should have been built some nine miles (14.5 km) further north on Cape Foulweather (Oregon names seem to reflect the nature of the coastline, Cape Disappointment and Destruction Island being the some of sites of other lighthouses). This rumor was unfounded. The lighthouse only abandoned because it was realized that the erection of a second light at nearby Yaquina Head had made it redundant.

However, the tower at Yaquina remained, and became the center of a gruesome ghost story at the end of the nineteenth century, in which it is alleged that a young girl called Muriel, the daughter of a local sea captain, visited the abandoned tower with some friends. As they were leaving, she went back in to retrieve a scarf that she had dropped, but she did not reappear. Her friends went in to look for her, but, to their horror, found only a trail of blood leading to an iron door that opened onto a deep shaft. Her body was never found

Above: Yaquina Bay, Oregon, US.

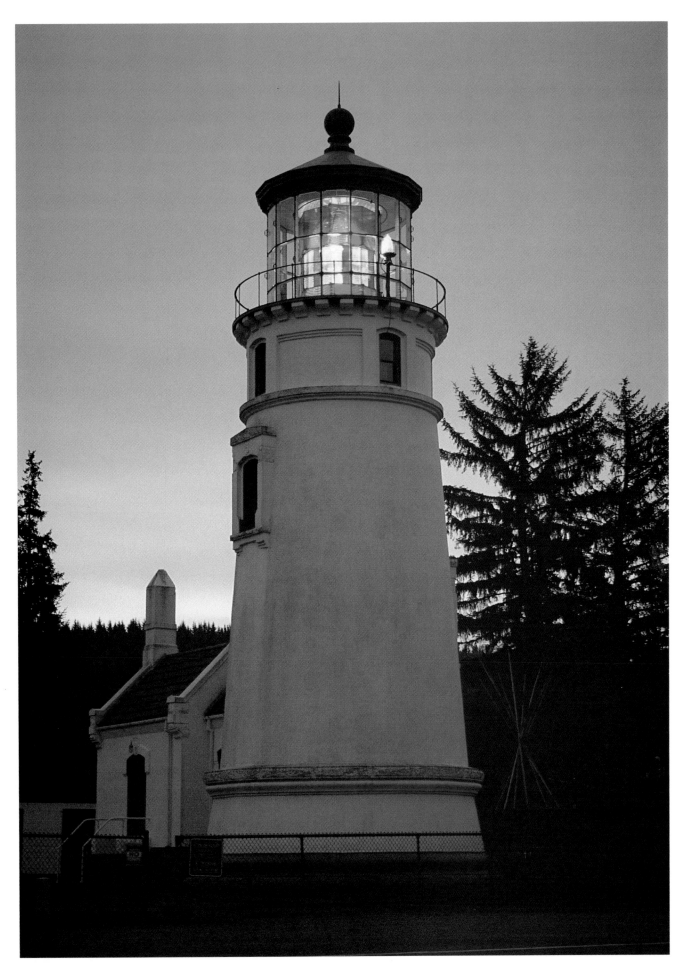

Above: Umpqua River light in Oregon, US.

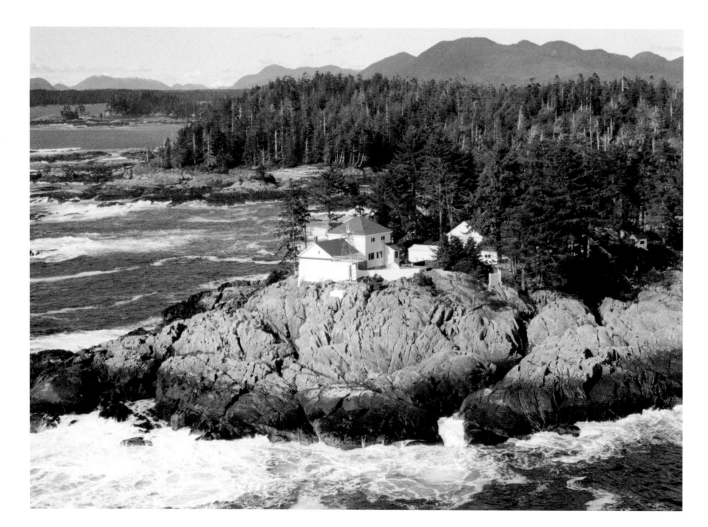

and it was suggested that she might have been murdered. Subsequently there were several reports of strange occurrences, most of which were associated with this story. However, later research indicated that the "ghost" could be traced back to a fictional story published in a magazine in 1899, and it seems that Muriel never existed at all. Nevertheless, lighthouses situated in lonely spots are a natural source of ghost stories and the nearby Yaquina Head lighthouse, completed in 1873, had its fair share also. One of these related to the death of a construction worker whose body could not be recovered from within the walls, while another alludes to an incident in the 1920s when one of the assistant keepers died of an illness while his companion was drunk. The head keeper who had gone ashore at the time subsequently lived in fear of the dead man's ghost and refused to go up to the lantern again unless accompanied by his faithful bulldog.

Oregon's oldest lighthouse is at Cape Blanco de Aguilar near the southern end of the state's coastline.

This was built in 1870 and the light was some 245 feet (74.3 m) above sea level although the actual tower was only fifty-nine feet (17.9 m) tall. It was visible from ships over twenty miles (32 km) out to sea but, as it turned out, they were not the only ones to make use of it. During World War II it was assumed that no Japanese warship or aircraft would ever come close enough to the U.S. mainland to warrant the extinguishing of the lights and other navigational aids. However on September 9, 1942, a Japanese submarine surfaced in the area and used the light to fix its position before launching a seaplane that flew inland and dropped incendiary bombs on the Oregon forests in an unsuccessful attempt to start some forest fires. This as the only recorded attack by aircraft on the United Sates during the entire war.

North of Oregon is the Canadian border and it is separated from the mass of Vancouver Island by the Straits of Juan de Fuca, which lead into Esquimalt Sound. Here, on the north side of the straits is the first lighthouse built on the western Canadian seaboard. Situated

Above: Ivory Island, British Columbia, Canada.

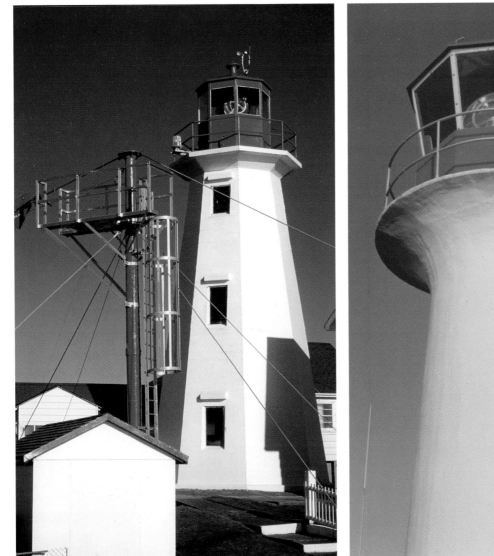

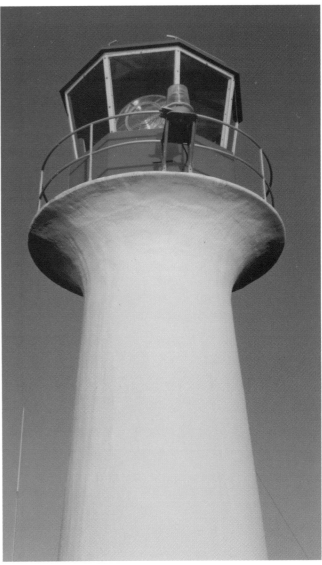

on Race Rocks, the light was completed in 1860 following a massive increase in seaborne traffic resulting from gold strikes in the Fraser River area, inland from what is now Vancouver. These rocks were washed by dangerous riptides and were a great hazard to shipping. As is often the case with lighthouses, its necessity was dramatically illustrated by the wrecking of a ship on the rocks only eleven days before it was commissioned. The tower is some 105 feet (31.9 m) high and the present, rather small, lantern is a modern replacement for the original, which burned colza oil and dog fish liver oil. The light remains in use today, and the granite tower is painted in an unusual black-and-white pattern to make it conspicuous as a day-marker. Over the years, the approaches to Vancouver and British Columbia were provided with additional lighthouses, including Carmanah Point in 1890 and Point Atkinson in 1912.

On the Pacific side of Vancouver Island, a lighthouse was erected at Estevan Point in 1909. The architect was Colonel William P. Anderson, Chief Engineer of the Department of Marine and Fisheries, and its particular significance was that it was one of the first major structures anywhere to be built of reinforced concrete. Its other claim to distinction is being the only place in Canada to have been the subject of a hostile attack since the War of 1812 between Great Britain and the United States. This is supposed to have occurred in 1942, when the area was shelled by a Japanese submarine. If their target was the lighthouse, their aim was poor, as it was undamaged. Although today classed by the Government as a National Heritage Building, the one hundred foot (30.0 m) high lighthouse remains fully operational, its flashing light visible up to eighteen miles (29 km) offshore.

Top left: Green Island, British Columbia, Canada.

Top right: Bonilla Island British Columbia, Canada.

Next page: Dryad Point, British Columbia, Canada.

The Hawaiian Islands are one of the fifty states making up the United States of America, but to reach them entails a 2,000 mile (3220 km) sea voyage westward from San Francisco. Forming the eastern end of a great undersea volcanic ridge, the islands are a major link in transpacific routes as well as being a desirable destination in their own right ever since their discovery by the British explorer Captain Cook in the eighteenth centu-

Top left: Diamond Head, Oahu, Hawaii, US.

Top right: Kilauea Point, Kauai, Hawaii, US

Above: Faro Punta Brava, Montevideo, Uruguay.

ry. They came under U.S. control in 1898 at which time the standard of marine navigation aids was extremely primitive. Although, for example, there were no less than nineteen lighthouses in the islands, only one was equipped with a Fresnel lens, the rest being little more than simple oil lanterns. It was not until 1904 that responsibility for these lights passed to the U.S. Lighthouse Board and work began to modernize and update them. A detailed report following an inspection at that time describes many light towers as wooden trestles with little rooms at the top where the lamps were placed.

At Kanahene Point on the south coast of the island of Maui, "two ordinary kitchen lamps" marked the low lava spit that ran into the ocean, and similar installations were noted at Lahaina, also on Maui, and at Laupahoehoe and Mahu Kona on the island of Hawaii. The light at Maalaea Bay on Maui consisted of an "ordinary red lantern hung from a post," while the Waiakea light, located on the southeast side of Hilo Bay, consisted of a city arc light with a red screen in front of it. The entrance to Hilo Bay was equipped with a little better light, which was composed of three small reflector lights situated on Paukaa Point. Barbers Point light and the Kalaeokalauu light on Molokai Island may have been better, with more substantial towers and small Fresnel lenses. Under the auspices of the Lighthouse Board, many of these were replaced and upgraded, and several new towers with powerful lights were erected over the years. On Oahu, on which Honolulu and Pearl Harbor are situated, these included Maka puu Head (1909) on the eastern extremity of the island, Diamond Head (just by the famous Waikiki Beach) in 1918, and Barber Point to the southwest in 1933. These all remain active today. The largest island of the group is Hawaii itself, dominated by two massive volcanic peaks. Its Cape Kumakahi is the easternmost point of the whole archipelago, and the light here was built in 1934. Almost at the other end of the islands and west of Oahu is Kauai, which has a number of lighthouses including the oddly-named Nawilwili Harbor light built in 1934. The older structure at Kilauea Point which dates from 1913

Above: Diamond Head, Oahu, Hawaii, US.Wilson's Promontory, Victoria, Australia.

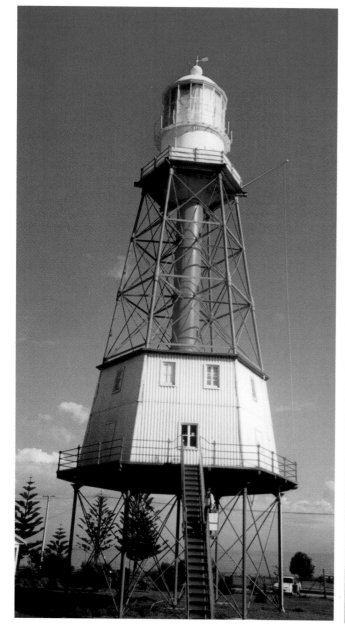

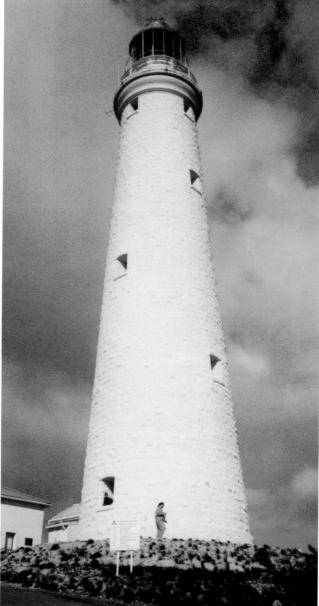

is no longer used but is a popular tourist attraction in a National Wildlife Park.

A much larger group of islands, over 3,000 miles (4,830 km) farther west make up Japan. which, until the mid-nineteenth century, had been isolated and self-contained. This might seem a far cry from today when the country is one of the world's great maritime and trading nations. Small islands, reefs, and rocky shoals surround the tortuous coast, and as might be expected there is a substantial network of lighthouses and other aids for the mariner. Interestingly, their first modern lighthouse was built in England in the late nineteenth century to a design by the Stevenson family. Here it was fitted with its light and optics for testing, before being

disassembled and shipped halfway around the world to Japan. Subsequently it formed the basis for the design and construction of many others around the Japanese coast.

Today, the northernmost lighthouse in Japan is at Sōya Misaki guarding the La Perouse Strait, which separates Hokkaido from the Russian Island of Sakhalin. At the other extreme, over 21° of latitude south on the small island of Hateruma Sima just to the east of Taiwan, is another lighthouse. In between are numerous other examples, including the world's tallest at Yamashita Park, Yokohama, although actually the light is carried on a steel lattice tower rather than a traditional stone structure. Nevertheless, it stands

Top left: Cape Jaffa, Kingston, South Australia.

Top right: Rottnest Island, Western Australia

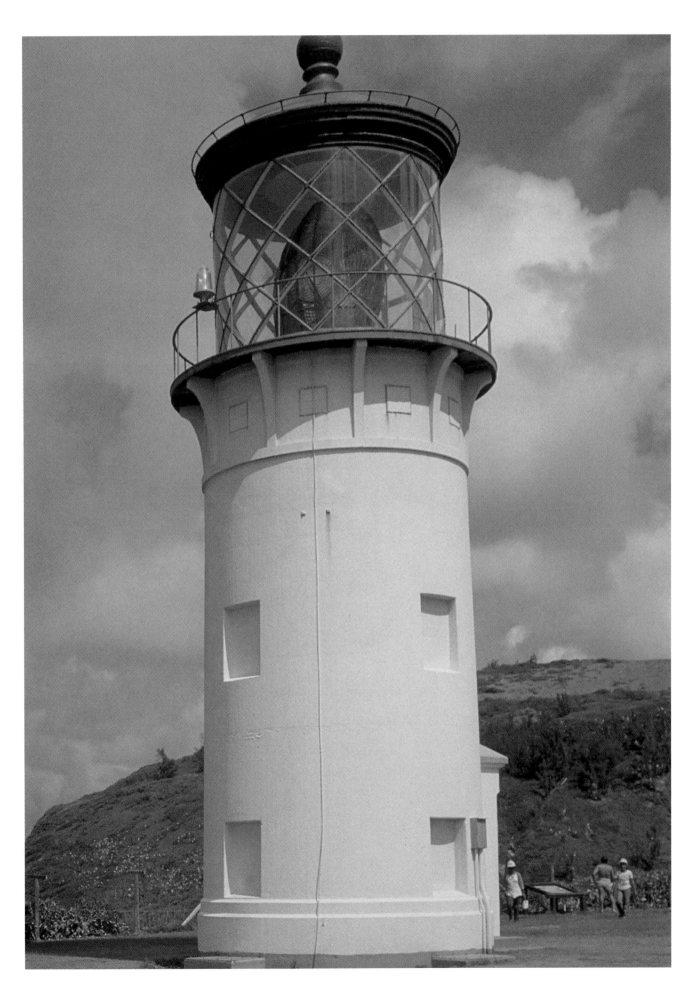

Above: Kilauea Lighthouse, Kauai, Hawaii, US.

Next page: Seaport near Oji Paper Company mill in Tomakomai, Japan.

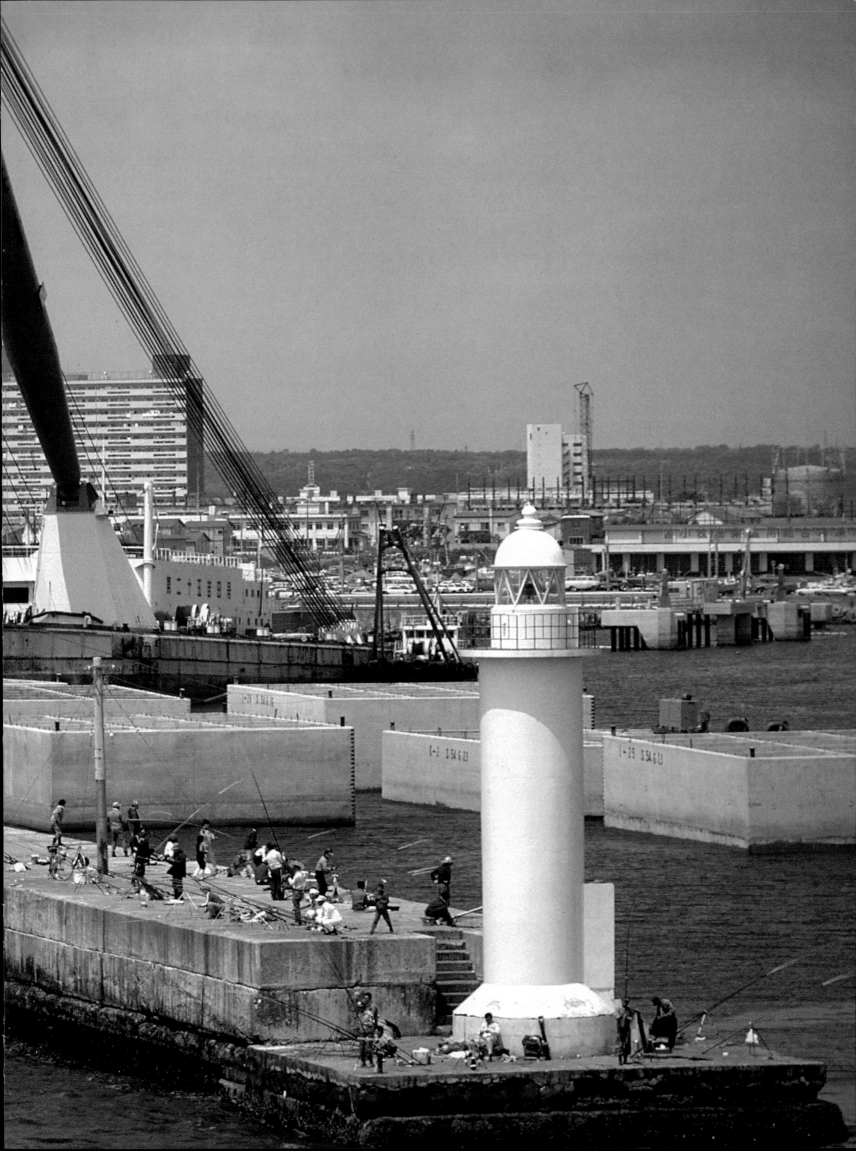

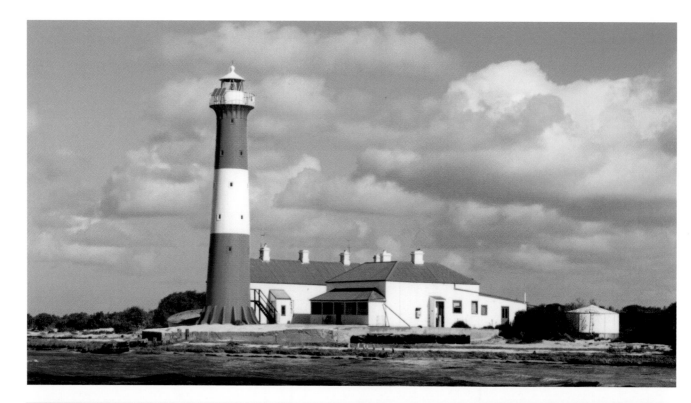

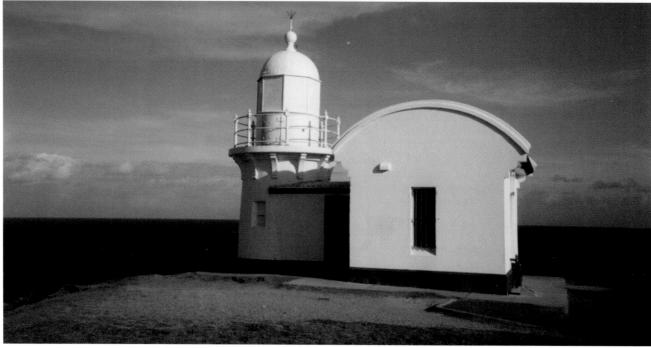

some 348 feet (106 m) high. The tallest traditional structure, a handsome white stone tower, is at Izumo Hino Misaki on a headland jutting out into the Korean Straits on the north side of the mainland of Honshu.

Across the Yellow Sea lay mainland China, and the Chinese also relied on British influence for their early lighthouses. Up to 1868, few if any lights existed, and the Chinese sailors rarely traveled at night. The increasing trade with western nations led to a need for a proper system of lights, and in 1868 Sir Robert Hart was appointed to head a new Customs Marine Department. Under the influence of this energetic civil servant, no less than sixty-four lights were officially listed by 1876. Although some of these were buoys or lightships, there were at least nine first-order lights. Many of these were of cast-iron construction, the prefabricated sections being made in England and shipped out for assembly.

Top: Troubridge Shoal, South Australia.

Above: Tacking Point, Port Macquarie, New South Wales, Australia.

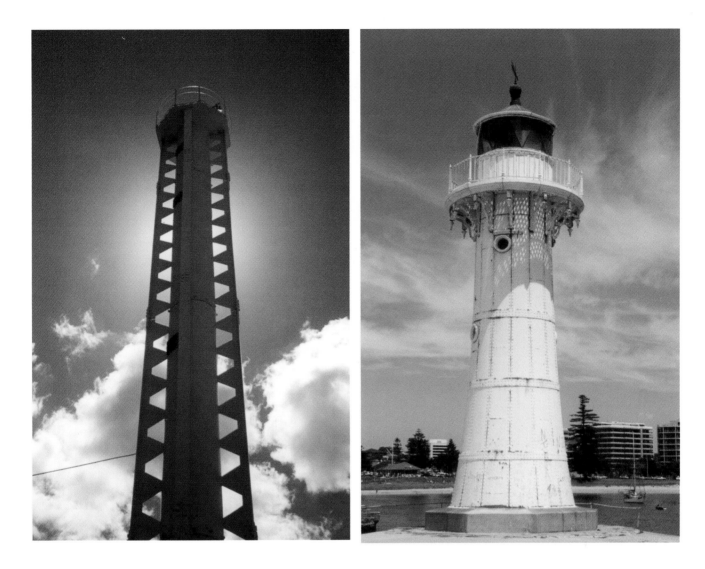

One of the most important of these was at Breaker point, forty miles (64.4 km) east of Hong Kong. This was a more traditional structure and took five years to build, its purpose being only too clearly illustrated by the loss of at least two ships in the area during its construction. It was first illuminated in 1880. Its rather checkered history included being taken over by Communist troops in 1932, following which the European keepers were abducted and never seen again.

A little to the west, another lighthouse was erected at Chilang Point and at one time its 930,000-candle-power light, fitted in 1929, was the most powerful in Southeast Asia (by comparison, Japan today has three lighthouses of two-million-candle power). Prior to that, in 1923, one of the Chinese keepers was drowned while on his way to take over a spell of duty. As result of this incident, the other Chinese keepers refused to sleep there at night for fear of his ghost, and it fell to the solitary European to keep all the night watches until a priest was able to come and exorcise the building.

Although these facts and stories relate to the lighthouses of this particular part of the world, there is clearly a common bond and theme running through the stories of lighthouses from around the whole world. The need for a light as a means of preserving life becomes overwhelming and a lighthouse is built, often of ingenious design and sometimes at great cost in both men and materials. The lights themselves were tended by men and women of great tenacity and courage, and often with exemplary devotion to duty. At the mercy of the sea, tides, and weather, they kept their lights shining for the benefit of all mariners whatever their nationality. Today, the human element is perhaps fading quickly and some of the romance has gone out of the lighthouse story, but the lights themselves still shine out, silent witnesses to the stirring stories of the past.

Top left: Calounra, Queensland, Australia.

Top right: Wollongong, New South Wales, Australia.

COMPILED BY THE U.S.

LIGHTHOUSE SOCIETY

Basis for selecting the number of light stations remaining in the U.S.

The listing of light stations was based on stations as opposed to towers. Some towers were never part of a manned station. The list includes any one-time manned station of which some structure remains. In a few cases the "classical" tower has been removed, but the dwelling, fog-signal house or some other combination of structures remain. In the case of a set of range lights, the site is considered one station. Where two towers remain, either as a two-tower station (Bakers Island, Cape Ann) or the original, and new tower still remain (Cape Romain, Cape Henry), the site is counted as one station. However, if the "new" tower is located a considerable distance (Point Loma), then it and the old tower are counted as separate sites or stations. Where the "house" structure of a caisson or screw-pile type structure has been removed, the site is not included. Non-federal lighthouses (private aids to navigation) are not included, nor are special towers like the William Livingston Memorial tower in Lake Erie, as it was never a manned station.

For further information see **sprice@comdt.uscg.mil**

A L A B A M A ③

Mobile Point (small tower only on fort)
Mobile Bay Middle Ground
Sand Island (tower only)

A L A S K A ⑭

Cape Decision
Cape Henchinbrook (tower only)
Cape Sarichef
Cape Spencer
Cape St. Elias
Eldred Rock
Five Fingers
Guard Island
Lincoln Rock (tower only)
Mary Island (tower only)
Point Retreat
Scotch Cap (mostly destroyed)
Sentinel Island (tower only)
Tree Point (tower only)

C A L I F O R N I A ㊱

Alcatraz (tower only)
Anacapa Island
Ano Neuvo Island (ruins)
Cape Mendocino (tower only relocated)
Carquinez Strait (relocated)
Crescent City (Battery Point)
East Brother Island
Farallon Islands
Fort Point (tower on parapet only)
Lime Point (fog-signal building only)
Mile Rocks (partially destroyed)
Oakland Harbor (relocated and a restaurant)
Piedras Blancas (lantern missing)
Pigeon Point
Point Arena

Point Arguello
Point Blunt (modern light station, not typical design)
Point Bonita
Point Cabrillo
Point Conception
Point Fermin
Point Hueneme
Point Loma (old)
Point Loma (new)
Point Montara
Point Pinos
Point Reyes
Point Sur
Point Vincente
Punta Gorda (tower only)
San Luis Obispo
Southampton Shoal (relocated)
St. George Reef
Table Bluff (all structures save tower in situ, tower relocated)
Trinidad Head
Yerba Buena Island

C O N N E C T I C U T ⑱

Falkner's Island (tower only)
Fairweather (Black Rock - tower only)
Great Captain Island
Greens Ledge
Latimer Reef
Lynde Point (at Saybrook)
Morgan Point
New Haven (Five Mile Point - tower only)
New London
New London Ledge
Peck Ledge
Penfield Reef
Saybrook Breakwater
Sheffield Island (at Norwalk)
Southwest Ledge
Stamford Harbor
Stonington
Stratford Point

D E L A W A R E (13)

Bellvue Range
Brandywine Shoal
Delaware Breakwater
Fenwick Island
Finns Point Range (tower only)
Fourteen Foot Bank
Harbor of Refuge
Liston Range
Marcus Hook Range
Mispillian Range
New Castle Range (tower gone)
Port Penn Range
Reedy Island Range

F L O R I D A (28)

Alligator Reef
Amelia Island
American Shoal
Anclote Key (tower only)
Cape Canaveral (tower Only)
Cape Florida (faux dwelling)
Cape San Blas
Cape St. George (tower leaning, house badly damaged)
Carabelle Beach
Carysfort Reef
Cedar Key (Horseshoe Key)
Crooked River
Egmont Key (tower only)
Fort Jefferson (tower on parapet only)
Fowey Rocks
Gasparilla Island Range (Boca Grande)
Hillsboro Inlet
Jupiter Inlet
Key West
Loggerhead Key
Mayport (tower only)
Pensacola
Ponce de Leon Inlet
Sand Key

Sanibel Island
Sombrero Key
St. Augustine
St. Marks

G E O R G I A (5)

Cockspur Island (tower only)
Little Cumberland (tower only)
Sapelo Island (tower only)
St. Simons
Tybee

H A W A I I (7)

Barbers Point (tower only)
Cape Kumukahi
Diamond Head
Kilauea
Makapuu Point (tower only)
Molokai
Nawiliwili

I L L I N O I S

Chicago Breakwater
Grosse Point

I N D I A N A

Michigan City

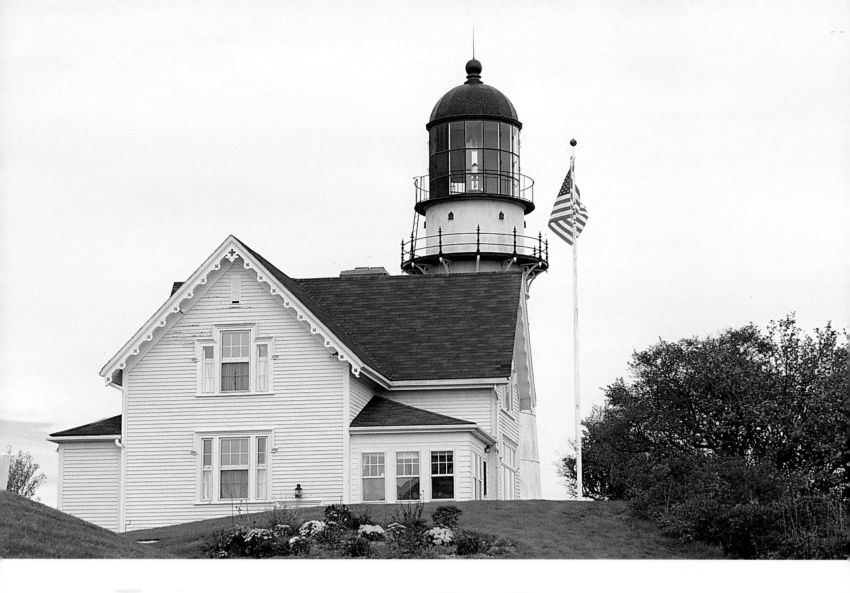

Above: Cape Elizabeth, Maine, US

APPENDIX

Goat Island

Goose Rocks

Great Duck Island

Grindle Point

Halfway Rock

Hendricks Head

Heron Neck

Indian Island

Isle Au Haut

Kennebec River Range

Little River

Libby Island

Lubec Channel

Marshall Point

Matinicus Rock

Mt. Desert Rock

Monhegan Island

Moose Peak (tower only)

Narraguagus (Pond) Island

Nash Island (tower only)

Owls Head

Pemaquid Point

Perkins Island

Petit Manan

Pond Island (tower only)

Portland Breakwater (tower only)

Portland Head

Prospect Harbor

Pumpkin Island

Ram Island

Ram Island Ledge

Rockland Breakwater

Saddleback Ledge (tower only)

Seguin Island

Spring Point Ledge

Squirrel Point

Tenants Harbor

Two Bush Island (tower only)

West Quoddy Head

Whitehead

Whitlock Mills

Winter Harbor (Mark I.)

Wood Island

M A R Y L A N D (18)

Baltimore

Bloody Point Shoal

Cove Point

Craighill Channel Range

Drum Point (relocated)

Fishing Battery (very bad shape)

Fort Carroll (small lantern on fort, poor condition)

Fort Washington (bell tower only)

Havre de Grace (Concord Point)

Hooper Strait (relocated)

Piney Point

Point Lookout

Pooles Island (tower only)

Sandy Point

Seven-Foot Knoll (relocated)

Sharps Island (leaning badly)

Thomas Point Shoal

Turkey Point (tower only)

M A S S A C H U S E T T S (49)

Annisquam

Bakers Island

Bass River (badly altered)

Bird Island (tower only)

Borden Flats

Boston

Brandt Point (an old structure/housing)

Butler Flats

Cape Ann (Thacher Island)

Cape Cod (Highland)

Cape Pogue (tower only)

Chatham

Cleveland Ledge

Duxbury Pier

East Chop (tower only)

Eastern Point

(The) Graves

Gay Head (tower only)

Great Point (reconstructed tower only)

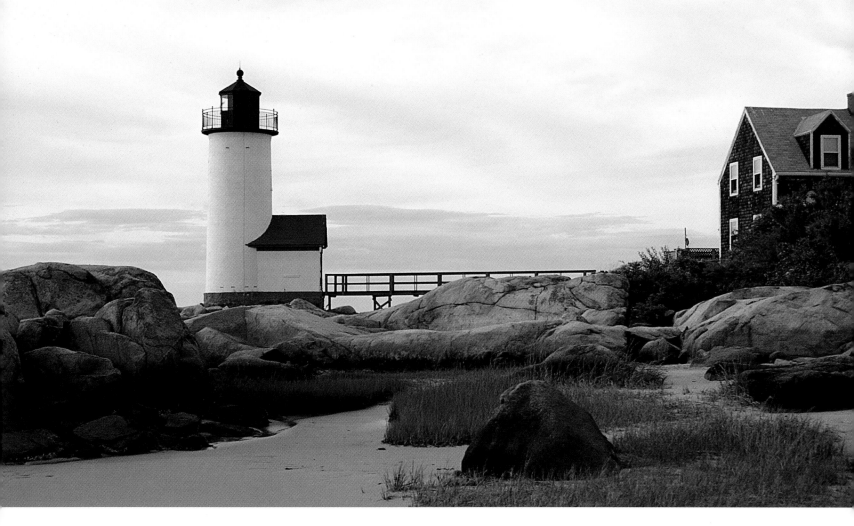

Edgartown (tower only)

Hospital Point Range

Hyannis

Long Island Head (tower only)

Long Point (tower only)

Marblehead (tower only)

Mayo Beach

Minots Ledge

Monomoy Island

Nauset Beach

Nauset (Three Sisters)

Ned Point (tower only)

Newburyport Harbor Range

Nobska Point

Pamer Island (tower only)

Plum Island

Plymouth (Gurnet)

Point Gammon (damaged tower only)

Race Point

Sandy Neck

Sankaty Head (damaged tower only)

Scituate

Stage Harbor (damaged tower)

Straitsmouth (tower only)

Tarpaulin Cove (tower only)

Ten Pound Island (tower only)

West Chop

Wings Neck

Above: Annisquam, Massachusetts, US.

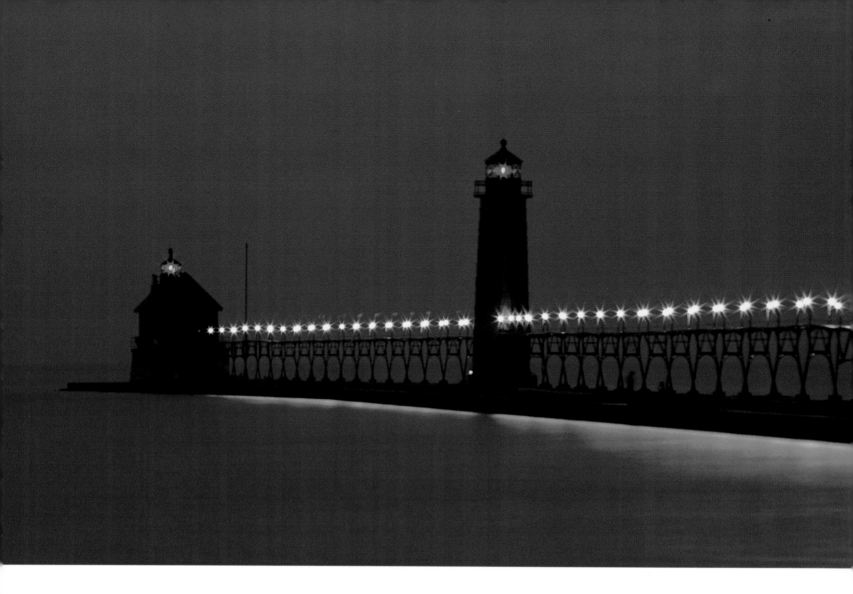

Above: Grand Haven Range Light, Michigan, US.

Manitou Island

Marquette Harbor

Martin Reef

McGulpin's Point

Mendota (Bete Gris)

Menagerie Island

Middle Island

Mission Point

Munising Range Lights

Muskegon Range Lights (towers only)

North Manitou Shoal

Old Mackinac Point

Ontonagon

Passage Island

Peninsula Point (tower only)

Poe Reef

Point Au Batques

Point Betsie

Point Iroquois

Port Austin Reef

Port Sanilac

Portage Lake Lower Entrance Range

Portage River

Poverty Island

Presque Isle (new and old)

Presque Isle Range Lights

Rock Harbor

Rock of Ages

Round Island (Mackinac Island)

Round Island (Mud Lake)

Saginaw River Range Lights

Sand Point (Green Bay)

Sand Point (Lake Superior)

Sands Hills

Seul Choix Point

Skillagalee (Ile Aux Galets - tower only)

South Fox Island

South Manitou Island

Spectacle Reef

Squaw Island

Squaw Point

St. Helena

St. Joseph

St. Martin Island

Stannard Rock

Sturgeon Point

Tawas

Thirty Mile Point

Thunder Bay Island

Waugoshance

Whitefish Point

White River

White Shoal

M I N N E S O T A (7)

Duluth North Pier

Duluth Range Lights

Grand Marais

Minnasota Point (hull of tower only)

Split Rock

Superior Pierhead Range

Twin Harbors

M I S S I S S I P P I (3)

Biloxi (tower only)

Chadeleur Island (tower only)

Ship Island (tower only)

N E W H A M P S H I R E (3)

Portsmouth Harbor

Isle of Shoals (White Island)

Whaleback

APPENDIX

N E W J E R S E Y (12)

Absecon (tower only)

Barnegat (tower only)

Cape May

Eastern Point (Maurice River)

Great Beds

Hereford Inlet

Miah Maull Shoal

Naves ink

Sandy Hook

Seagirt

Ship John Shoal

Tinicum Rear Range Light

N E W Y O R K (65)

Barcelona (Lake Erie - lantern missing)

Barber Point (Lake Champlain)

Bluff Point (Lake Champlain)

Braddick Point (Lake Ontario - lantern missing)

Buffalo (Lake Erie - only)

Buffalo South Breakwater (Lake Erie)

Charlotte-Genesee (Lake Ontario)

Cedar Island

Cold Spring Harbor (relocated)

Coney Island

Conover-Chapel Hill Range

Cross Over Island (St. Lawrence River)

Crown Point (Lake Champlain - tower only)

Cumberland Head (Lake Champlain)

Dumpling Island

Dunkirk (Lake Erie)

Eatons Neck

Elm Tree - New Dorp Range

Esopus Meadows

Execution Rocks

Fire Island

Fort Niagara

Fort Wadsworth (lantern on fort, dwelling removed)

Galloo Island (Lake Ontario)

Great Beds

Horse Island (Lake Ontario)

Horseshoe Reef (badly deteriorated)

Horton Point

Hudson-Athens

Little Gull Island

Lloyd Harbor

Montauk Point

North Brother Island (tower portion of house/tower missing, abandoned)

North Dumpling Island

Ogdensburg (Lake Ontario)

Old Field Point

Old Orchard Shoal

Oswego Breakwater (Lake Ontario)

Plum Island

Point Aux Roches (Lake Champlain)

Point Orient

Princess Bay (lantern missing)

Race Rock

Robbins Reef

Rock Island (St. Lawrence River)

Romer Shoal

Roundout II

Salmon River (Selkirk - Lake Ontario)

Sands Point

Saugerties

Sister Island (St. Lawrence River)

Split Rock (Lake Champlain)

Sodus (Lake Ontario)

Staten Island (tower only)

Statue of Liberty

Stepping stones

Stony Point (Hudson River)

Stony Point (Lake Ontario)

Stratford Shoal

Sunken Rock (St. Lawrence River)

Tarrytown

Thirty Mile Point (Lake Ontario)

Throgs Neck (Dwelling only)

Tibbets Point (Lake Ontario)

West Bank

N O R T H C A R O L I N A (9)

Bald Head (tower only)
Bodie Island
Cape Hatteras
Cape Lookout
Currituck Beach
Oak Island
Ocracoke
Prices Creek (only tower without lantern remains)
Roanoke River (relocated)

O H I O (11)

Ashtabula
Cleveland West Breakwater
Conneaut
Fairport
Grand River
Lorain
Marblehead
South Bass Island
Toledo Harbor
Turtle Island (mostly gone)
West Sister (tower only)

O R E G O N (9)

Cape Arago (tower only)
Cape Blanco (tower only)
Cape Meares (tower only)
Coquille River (tower only)
Heceta Head
Tillamook Rock
Umpqua River
Yaquina Bay
Yaquina Head (tower only)

P E N N S Y L V A N I A (2)

Pennsylvania (2)
Erie (land)
Erie Presque Isle

P U E R T O R I C O (16)

Arecibo
Cabras Island
Cape Rojo
Cape San Juan
Cardona Island
Culbrita
Guanica
Mona Island
Muertos Island
Point Borinquen
Point Figuras
Point Jiguero
Point Mulas (badly damaged)
Point Tuna
Port Ferro
Port San Juan

R H O D E I S L A N D (21)

Beavertail
Block Island North
Block Island SE
Bristol Ferry (faux lantern)
Castle Hill (tower only)
Conanicut Island (no lantern)
Conimicut
Dutch Island (tower only)
Goat Island (Newport Harbor - tower only)
Hog Island Shoal
Ida Lewis Rock (badly reconfigured, yacht club)
Nayatt Point
Plum Beach

<div style="text-align:left">A P P E N D I X</div>

Point Judith

Pomham Rocks

Popular Point

Prudence Island (tower only)

Rose Island

Sakonnet

Warwick

Watch Hill

S O U T H C A R O L I N A (7)

Cape Romain (two towers)

Georgetown

Haig Point Rear Range

Hilton Head (on golf course)

Hunting Island (tower only)

Little Cumberland

Morris Island (tower only)

T E X A S (8)

Aransas Pass

Bolivar Point

Brazos River

Galveston Jetty (lantern missing)

Half Moon Reef (relocated)

Matagorda

Point Isabel (tower only)

Sabine Bank

V E R M O N T (5)

Colcester Reef

Isle La Motte

Juniper Island

Lake Moggagog

Windmill Point

V I R G I N I A (9)

Assateague (tower only)

Cape Charles (tower only)

Cape Henry (old and new tower)

Jones Point

New Point Comfort (tower only)

Newport News Middle Ground

Old Point Comfort

Thimble Shoal

Wolf Trapp

W A S H I N G T O N (21)

Admiralty Island (fake lantern)

Alki Point

Browns Point

Burrows Island

Cape Disappointment (tower only)

Cape Flattery

Destruction Island

Ediz Hook

Grays Harbor (tower only)

Lime Kiln

Marrowstone Point

Mukilteo

New Dungeness

North Head

Patos Island (tower only)

Point No Point (tower only)

Point Robinson

Point Wilson

Slip Point (no tower)

Turn Point

West Point

W I S C O N S I N (29)

Algoma

Bailey's Harbor

Bailey's Harbor Range

Cana Island

Chambers Island

Devils Island

Eagle Bluff

Kenosha

Kewaunee Pierhead

La Pointe

Long Tail Point (hull of tower only)

Manitowoc Breakwater

Michigan Island

Milwaukee Breakwater

Milwaukee North Point

Minneapolis Shoal

Outer Island

Pilot Island (Port des Mort)

Plum Island

Port Washington Breakwater

Pottawatomie

Racine Reef

Raspberry Island

Sand Island

Sheboygan Breakwater

Sherwood Point

Sturgeon Bay Canal Range

Two Rivers Point (Rawley Point)

Wind Point